(Content)

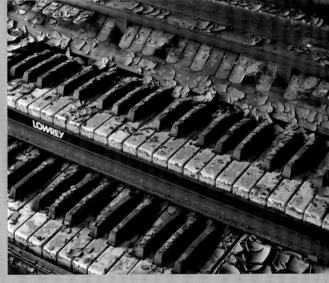

Photograph © Samuel Portera

(Transformation)

Before (During) After
Twelve Photographers' Visual Reactions to Hurricane Katrina

We saw it.
We captured it.
We are forever changed by it.

Before During After is a visual and literary narrative of how Hurricane Katrina has transformed the lives and work of twelve photographers from Southeast Louisiana. Five years after the storm's wake, we look back to discover Katrina's imprint on the creative expression of each artist. Some changes are dramatic, others apparently subtle—all are significant. The effect of a commonly experienced catastrophe is transforming. The photographers witnessed the changes through their lens and interpreted these individually with images they created before, during and after Katrina.

The book emphasizes, not only the effect Hurricane Katrina has had on these photographers, but also the way individuals are influenced by their environments, particularly in times of dramatic upheaval. Adding depth to the pictorial representation, each photographer has written an intimate account of how Katrina changed his or her life, work and vision of the future.

Photographers

Eric Julien, Elizabeth Kleinveld, Rowan Metzner, David Rae Morris, Thomas Neff, Samuel Portera, Frank Relle, Jennifer Shaw, Mark J. Sindler, Zack Smith, Jonathan Traviesa and Lori Waselchuk.

Writers

John Biguenet, Steven Maklansky and Tony Lewis, Ph.D.

Contents

Steven Maklansky's introduction shares his insights on the emotional impact the storm left on the photographers who documented it, suggesting that their later, more reflective work offers them and us a type of salvation from the wreckage.

John Biguenet's foreword depicts the city on the eve of the storm, taking us from the time just before the levees broke to the first winter after Katrina.

Tony Lewis's essay on disaster representations in art places Hurricane Katrina coverage in a continuum of images that shock a society and call the viewers to action, to right the wrongs of the past, wherever possible.

The book ends with an afterword by John Biguenet, who emphasizes the importance of chronicling the destruction of one of America's greatest cities. He also gives us an intimate account of how the storm changed his own creative process. He observes: "All of us, in one way or another, depicted life among the ruins."

BEFORE

LOUISIANA PHOTOGRAPHERS' VISUAL REACTIONS TO HURRICANE KATRINA

(DURING)

ESSAYS BY JOHN BIGUENET, STEVEN MAKLANSKY AND DR. TONY LEWIS

AFTER

FOR UNCLE JACK AND TOMMY STAUB

CONTRIBUTORS

Elizabeth Kleinveld
Project Director

Nathanja van Dijk
Project Assistant

Rowan Metzner
Photo Editor

Constance Adler
Anne Gisleson
Michael Martin
Text Editors

Tom Varisco, Tom Varisco Designs
Creative Director

Jean Caslin and Diane Griffin Gregory
Caslin Gregory & Associates
Project Consultants

Diane Barber
Tony Lewis, Ph.D.
Exhibition Curators

Diane Barber, DiverseWorks Art Space
Hope Goldman Meyer, FixNOLA.org
Fiscal Agents

Cover photograph of piano keys © Samuel Portera
Inside front cover photograph © Elizabeth Kleinveld

DiverseWorks Art Space (Houston, Tx.) hosted the first venue of this traveling exhibition from September 10 to October 16, 2010.
This program is supported in part by Humanities Texas, the state partner of the National Endowment for the Humanities.
Partial funding for this publication is provided by a grant from from the Eleanor and Frank Freed Foundation.

Library of Congress Control Number: 2010927783
ISBN 978-1-60801-023-3

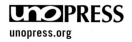
unopress.org

(Acknowledgments)

DiverseWorks

Diverseworks is a non-profit art center dedicated to presenting new visual, performing, and literary art. It is a place where the process of creating art is valued and where artists can test new ideas in the public arena. By encouraging the investigation of current artistic, cultural and social issues, DiverseWorks builds, educates, and sustains audiences for contemporary art.

DiverseWorks Underwriters: Academy for Educational Development; The Alice Kleberg Reynolds Foundation; The Andy Warhol Foundation for the Visual Arts; Anonymous; Artadia: The Fund for Art and Dialogue; Brown Foundation, Inc.; The City of Houston through the Houston Arts Alliance; Cullen Trust for the Performing Arts; Doris Duke Charitable Foundation; Houston Endowment Inc.; Louisa Stude Sarofim Foundation; MAP Fund/Creative Capital; Mid-American Arts Alliance; National Endowment for the Arts, a federal agency; National Performance Network; New England Foundation for the Arts; Texas Commission on the Arts; The Wortham Foundation Inc.; University of Houston

Patrons: British Council; Eleanor and Frank Freed Foundation; Greater East End Management District; Humanities Texas, the state partner of the National Endowment for the Humanities; Nimoy Foundation; Shell; Susan Vaughan Foundation; Visual Artists Network

Major Donors: Husnain Bajwa; Rosalie Buggs; Michael Clark & Sallie Morian; The Clorox Company; Brian & Shirley Colona; Cox Hardware Inc; James Dannenbaum; Glen Gonzalez; Greater Houston Visitors & Convention Bureau; John Guess, Jr. & Melanie Lawson; Houston Community College-Eastside Annex; Patrick & Tracey Keegan; Fritz Lanham & Kellye Sanford; Harris County Commissioner El Franco Lee; Sacha Nelson & Iris Trent Siff; Regulatory Economics Group LLC; RoachGannon, LLP; John & Pauline Smart; Vinson & Elkins, LLP; Bob & Lillian H. Warren

Louisiana State Museum

Since 1905, the Louisiana State Museum has recognized that contemporary events will eventually become history. The institution and staff are constantly working to preserve the past while capturing the present, with the goal of providing the communities we serve, both local and global, access to Louisiana's unique and living culture. The buildings that house LSM's collections and exhibits are culturally and architecturally significant. Our New Orleans properties are some of the more important buildings in the French Quarter—a neighborhood listed as both a National Historic District and a National Landmark. They are the gateway through which the past becomes relevant to the present.

In the aftermath of Hurricane Katrina, there has been a renewed sense of urgency and desire to keep the traditions of New Orleans and Louisiana alive. Faced with perhaps the greatest catastrophe the region and possibly the nation have experienced, the loss of our culture was a real possibility. From the bits that make up daily life to the annual grand celebrations of living, the people of Louisiana have shown that life continues, that our unique way of life cannot be easily destroyed, and that it must be preserved.

Living with Hurricanes: Katrina and Beyond, a major new exhibition opening October 2010 at the Louisiana State Museum in New Orleans, explores the history, science and dramatic human experience of these enormous storms. Using personal testimonies, rich media, and iconic objects collected in the immediate aftermath of Hurricanes Katrina and Rita in 2005, Living with Hurricanes also celebrates the spirit of service and resilience in the face of catastrophe.

Continuing the theme of resilience, the Museum will host an exhibit from Before During After in early 2011.

(Introduction)

by Steven Maklansky

This is different. This is not just another exhibition or book of photographs meant to document and encapsulate the tragic destruction, desolation, and despair that Hurricane Katrina precipitated on New Orleans. This book is not intended as an instructive exposition on the city's recent history. Nor does it analyze the extent of its recovery. This book is not about what people saw but how what they have seen has affected them. Them, in this case, are the twelve artists who are profiled in these pages.

First you will see images that each produced *before* Katrina passed. New Orleanians often refer to this era as "pre-K". Not only does this save two syllables, but its alternative meaning also refers to a period of early childhood education. So the use of "pre-K" betrays a certain longing for those halcyon days when we still had neighbors and neighborhoods. This was a time when we had an innocent faith in the Army Corps of Engineers' ability to keep the water out and government agencies' ability to get emergency supplies in.

Next you will see work that was produced *during* Katrina, a period here defined, not just by a few days of bad weather, but stretching from the evacuation through the harrowing days of deluge, including the weeks, months and years of response, recovery and rebuilding that followed.

Then you can ponder their more recent efforts, in part to gauge the effect of the catastrophe on artists' psyches, but also as a means of ascertaining whether an era that we might comfortably refer to as *after* Katrina has finally begun.

Before Katrina was a time when a New Orleans photographer or artist might have focused on any subject. Indeed for many decades, part of what attracted so many artists to New Orleans was its cultural diversity, which helped account for its seemingly endless sources of artistic inspiration. Of course, New Orleans had history. No other major American city is so connected and enamored with its past. Look to the city's reverence for jazz, the age of its restaurants, the traditions of Mardi Gras celebrations, and especially the city's architecture. Look not just in the fabled French Quarter, but also in the vernacular architecture of New Orleans's residential neighborhoods, spanning from Lakeview to the north, Algiers to the south, Carrollton to the west, and the Lower 9th to the east. The built environment of pre-K New Orleans had an authenticity that only happens through the accumulation of gradual change and when roots are well established.

New Orleanians are remarkable in their desire to stay put. When Katrina loomed, however, almost everyone who could depart did so. Most took only a few days' worth of clothing because they believed they would return when the power came back on. What they left behind was not just cherished personal belongings, but also a big easy macramé of cultural and historical continuity that was fundamental to New Orleans and significant to the artists who lived here or cared about it. Though it was surrounded by water, New Orleans was just not ready to handle a watershed event. Life in our city (and the artists who pondered it, were inspired by it, reflected upon it, and documented it) was about to change. What a disaster!

There is a bell curve to disaster photography. The first image of an accident is often taken almost by accident. People have

a camera in their hands (or more likely a cell phone equipped with one in their pockets) when something unusual and terrible happens in close proximity. Photographs created in such circumstances tend to be blurry and poorly composed, which only heightens our perception of their timely authenticity.

Hurricanes, however, do not come upon us unexpectedly. Instead, they are relentlessly forecasted for days. Thus the incline up the bell curve of photographing them is particularly steep. Although most people had fled by the time Katrina made landfall, there was plenty of time for the photographically inclined to position themselves on location. The spotlight was on. The cameras were loaded. The water came in. Houses crumbled or floated off their foundations. Cars and boats ended up in trees. Life and lives were washed away. As any break in what we perceive to be the normal pattern of life brings with it a corresponding increase in our observational inclinations, it was all too disturbingly, unavoidably photogenic. Such is the common function of journalism. The difference with Katrina was the vastness and totality of the destruction. To see something *not* destroyed was the "new noteworthy." No matter how valiant the photojournalists, nor how great the capacity of their memory-cards (nor how large the squadrons of helicopters and boats on which they might have caught a ride) not even a battalion of professional photographers could have fully documented what had happened to New Orleans. Yet, thousands of additional cameras were on the way.

The water slowly drained away, and people slowly seeped in. Volunteers came to assist, laborers came to work, soldiers came to patrol, insurance agents came to adjust, tourists came to gape, and New Orleanians came home. Normally they would have gone about their daily business pretty much focused on the grim tasks at hand, as opposed to focusing a camera on the world around them. This era of communal despair and common witness, however, was the apogee of the disaster photography bell curve. Back then every few steps you took in New Orleans always seemed to require the proverbial step back—an interruption from your course of action, not to take it easy, but to take it in. The New Orleans landscape, which for approximately two weeks had become the New Orleans seascape, was now an apocalyptic vision to behold. It was hard not to stare. Conditioned as we now are to take pictures of memorable or unusual or extraordinary events, many responded by taking pictures. Still, it was hard to take.

Artists and photographers, whose work pre-K was as diverse as New Orleans itself, were not immune to the coercive and narrowing effect of their new catastrophic circumstances. The New Orleans that they knew (perhaps more intensely than others who did not share their profession's requirements of contemplation) had drowned, and they were grieving its loss. Look at the twelve sets of images contained in this book that these artists produced *during* Katrina and see if you get a sense of how compellingly and inexorably Katrina filled their viewfinders.

Then turn the page and look for a change. Look at the works made *after* Katrina by each artist and try to discern a difference. See if they've really come through, if they've rescued themselves from the disaster. Have they been healed?

Assessing an artist's psychological condition by examining the artist's own creation poses a problem even more quixotic than attempting the same task with a work that *depicts* the artist. As none of the works contained in this catalog was intended by the artist to be a self-portrait, we must be cautious and even skeptical about examining an image in the hope of formulating a diagnosis.

Perhaps this book is not about what happened to them, after all. Maybe it's about what we want to be sure is happening to us. We know that life in New Orleans will never be what it was *before* Katrina. Despite the all-encompassing tragedy that we saw documented in the photographs taken *during* Katrina, what we get in these pages is nothing more than a little bit of artistic assurance and nothing less than a big hint of salvation. Even a glimpse of an *after* (Katrina)-life feels like a pretty heavenly experience.

(Foreword)

A Letter from Atlantis
by John Biguenet

Imagine a city.

Begin with its old quarter, a grid stretching perhaps six blocks inland from the eleven blocks that hug a riverbank congested with moored ships and bleating ferries. Line each narrow street and cobblestone alley with an unbroken façade of charming shops and cottages. The tropical sun that bakes the brick-and-stucco walls is unrelenting this time of year, so give each upstairs apartment a balcony, festooned with wrought-iron railings, to cast shade over the sidewalks below.

Now fill those pavements with knots of tourists gawking at the quaint architecture and with locals jostling past them on the way back to work after leisurely lunches in the fine restaurants for which the city is known.

Let the humid afternoon warmth damp the din of commerce and mute the clack of mule hooves and iron-shod wheels, the screech of automobiles, the jingle of coins dropped into a street musician's hat, the tolling of the cathedral's bell, the interrogative horns on the river.

Thicken the air with sweet olive, coffee, rotting fish, gardenias, and burnt sugar. Allow the heavy buildings to waver in the heat.

And provide every home there with someone writing at a desk or stirring a kettle of soup in the kitchen or dozing on an old couch. Let their children, playing in patios fringed with palmetto fronds bobbing in a warm breeze, squat beside the shallow pools of ornate fountains to tease golden fish feeding on mosquito larvae.

Now spread the rest of the city across a low plain wedged between a long crook of the river and the vast bay to the north. Erect office towers, an opera house, universities, theaters, hospitals, schools, a stadium, factories, churches, an aquarium, warehouses, museums, stores, statues of heroes, a train station, and two hundred thousand homes.

Divide the whole place into Irish neighborhoods and Italian, German and Vietnamese, Latin American and French. But reserve half the town for Africans. Invent an accent for them all to speak.

Set a fleet of small shrimp boats afloat on the bay, dragging their nets behind them. Loose a tide of cars down the highways that crisscross the city and arc over the river in broad bridges. Speckle the sky with planes banking toward the airport.

Have one, two, three thousand phones begin to ring. Suffuse the chatter of half a million people with coughs and curses, whispers and wheezes. Let a hundred dogs bark, fifty doorbells squawk their greetings, two hundred thousand television sets hawk the news, and a single lion in the zoo yawn. Provoke laughter until it ripples across the whole city.

Now—while they're still laughing—unpeople the place. Scatter in boarded-up houses, especially in the poorest neighborhoods, twenty-five, fifty, maybe eighty thousand men, women, and their children. But evacuate everyone else. Unleash a few dogs and cats to stray in search of food. Let the traffic lights continue to blink.

Have a damp breeze gust out of the southeast. Do not be distracted as oaks begin to shudder, loose weatherboards slap their houses, halyards clatter against the masts of sailboats moored in the agitated bay.

Darken the sky; sustain the wind as it stiffens into a gale. Let the pelting rain arrive in bands, each heavier than the one before,

until a merciless fist of wind sheathed in a glove of iron-gray water shatters windows in every house, smashes storefronts, snaps trees in half, batters roofs, flattens fences, rips signs from their poles. Hours later, as the storm trails north, shred the clouds with slashes of blue. Let people poke their heads out of doors, astonished by the freshly scoured sky. Gather them in the street, everyone ebullient that they have survived.

But while they regale one another with tales of what they've all just endured, notice how sand is bubbling along the base of the levees that protect their neighborhoods from drainage canals swollen with water from the bay. And a few minutes later, when the levees begin to collapse, one after another, note how shallow are the flood walls that pivot open as the water sluices, then cascades into the city.

Let the unchecked flow of warm salt water wash away houses abutting the levees, upend automobiles in driveways, gouge off corners of homes blocks away, topple light poles, and take more and more of the crumbling levees with it as the flood deepens.

As darkness falls across the city and people sleep, not yet aware of the breaches, fill the streets with water, gutter to gutter. Have it lap across the sidewalks and through picket gates, over the low azalea bushes blooming in gardens, up the steps and onto front porches, seeping under doors, then tamping at the windows, and finally settling just below the eaves.

The next morning, begin to strew human corpses here and there. Behind the locked door of a nursing home, heap thirty frail bodies. Then crowd forty more dead amid a pile of wheelchairs in a hospital stairwell. Let a whole family die trapped in their attic, not having thought to bring an axe to cut their way out through the roof.

Assemble the dispossessed still left in the city on outcroppings of concrete, highway overpasses, the raised terraces of public buildings. Withhold water from them and food. Let the dead rot among the living.

Ignore the stench rising from the fetid swamp that, mere days ago, was a great city and look out across the place you have dreamt. But do not allow yourself to weep at what you see. The water is too deep already.

You think you have come to the end of it, this nightmare, but it is only just beginning. Loose mobs of looters on the city's shopping district. Let them burn what they cannot carry away. Pack thousands and thousands of citizens in a sweltering stadium and a convention center, with neither running water nor working toilets, then observe how these people who have lost everything minister to one another, maintain what dignity they can muster, offer their sympathy to others, rebuke the lawless, protect the vulnerable. Do allow one government official to send word to the capital of the unfolding catastrophe, beg for supplies and personnel, and wait—surrounded by suffering—as help fails to arrive.

While the whole world watches in horror, let it go on like this for days. Then decree the abandonment of the city. Order the few troops who have finally arrived to drive out all its citizens. Scatter them across the country in makeshift shelters.

Keep the temperature in the nineties, and let the standing water rot the city for weeks. Study what salt water does to a house, to its sheetrock, to its insulation, to its door frames and studs. Marvel at the intricate designs of mold spiraling up walls, over furniture and artwork; wonder at its vibrant colors, the orange mold and the brown, the golden and the red as it thickens into delicate fur. Observe the shriveling of plants, the bleaching of grass.

Encourage politicians to denigrate the victims of the collapsed levees—which they themselves have refused to provide funding to strengthen year after year—for choosing to live in a city protected by levees built by the government they administer.

A month later, after the water has drained away, welcome back stunned evacuees to uninhabitable houses. Have no place for them to live, no shops open, no schools, no gas stations. Impose a curfew enforced by armed soldiers.

Line the streets of the city with reeking refrigerators

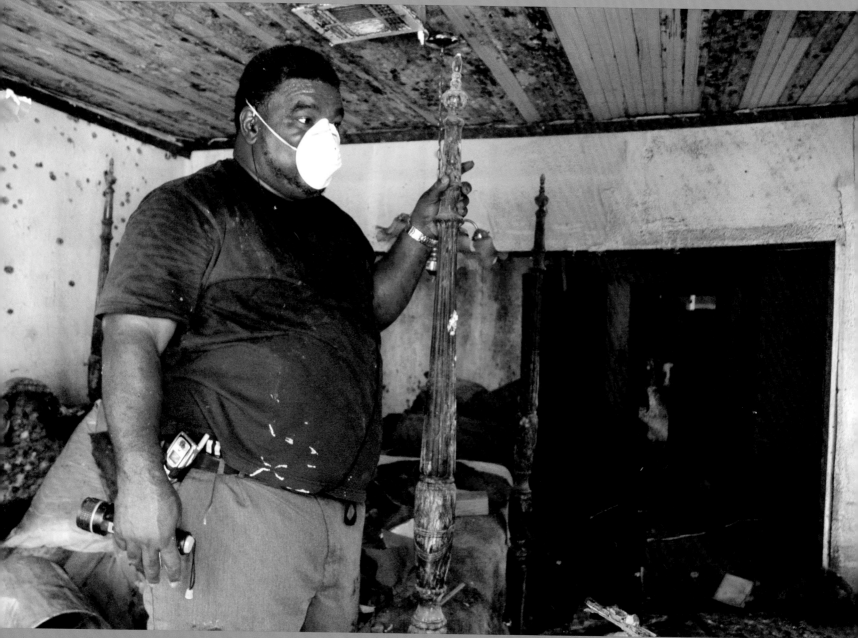

Photograph © David Rae Morris

seething with flies. Heap sidewalks with ragged slabs of stained sheetrock, ripped-out cabinets, appliances sloshing with water. Mound still-damp insulation, moldy carpets, stained clothes, sopping wet mattresses until they spill into the gutter. Scattter debris—broken chunks of metal, shards of glass, rusted nails—down every street.

Hint that whole neighborhoods will be demolished, but decline to specify which homes will be bulldozed. Leave unanswered all the questions of those not yet able to return. Wonder aloud why they would even want to return to their houses. Suggest they need to move on with their lives.

As winter arrives, keep stores shuttered because no workers can be found. Let families live by candlelight in the unheated homes they have gutted. Have businesses begin to declare bankruptcy. Do nothing as doctors and lawyers see their practices shrivel and fail. Raise rents two and three times over their pre-flood levels because so little housing was spared by the water. Leave most of the city dark at night and uninhabited. Tally the suicides.

Encourage the nation to turn to other matters as the place you have dreamed withers. And as you watch it fade away, imagine one more thing: how history will judge a country that let New Orleans, one of the world's great cities, die.

unanswered

questions

(Jennifer Sh

Before Katrina, I spent several years photographing post-industrial urban landscapes along New Orleans's Mississippi riverfront. After two months in post-Katrina exile, our family returned home, but it took several more months before I could bring myself to look at the city's vast devastation. Eventually, as a photographer living in New Orleans at that critical moment in its history, I felt compelled to bear witness.

In early 2006, I spent time documenting the storm's unbelievable destruction, resulting in the "Aftermath" portfolio. My work before and after the hurricane are actually quite compatible—my eye has always been drawn to objects in an elegant state of decay with the resulting images becoming portraits of things and times left behind. When seen side by side, the line between these pre- and post-K images is often unclear.

Focusing on the havoc was part of the healing process for me, but at a certain point I realized that the hurricane story I really needed to tell was my own. In the summer of 2006 I embarked on a radically different approach. I began shooting in color and employed toys to narrate my family's evacuation saga, including the birth of our son on the day Katrina hit. Where I used to find inspiration in the world around me, documenting things as I found them, I began instead to create a world in miniature—painting and posing tiny characters and props.

Photographing these tiny worlds was a wonderful catharsis for working through my post-hurricane anxieties. Recreating scenes within a timeline to illustrate my family's journey, with all its highs and lows, helped me come to peace with the physical and emotional upheaval that Katrina wrought.

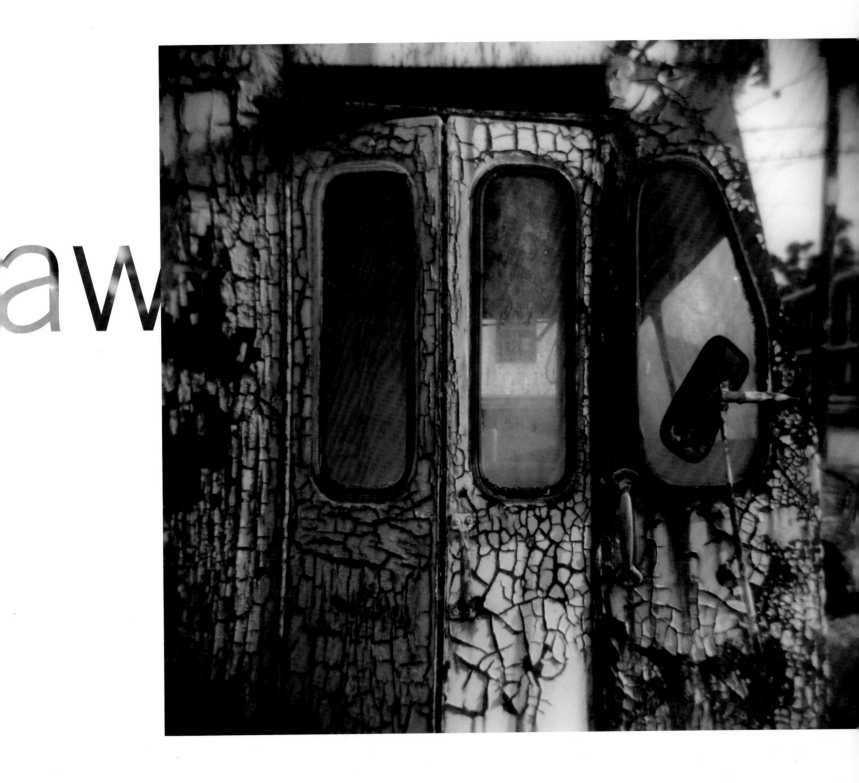

aw

times left behind

post-industrial land

scapes

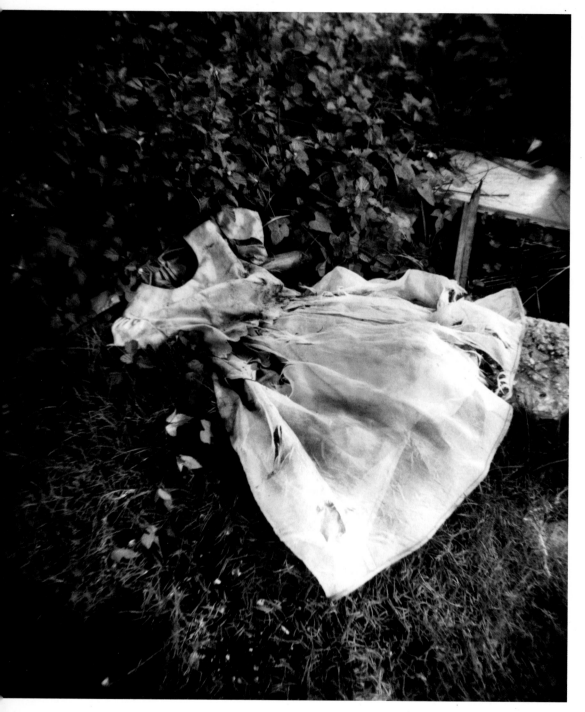

of

decay

create

a world

in miniature

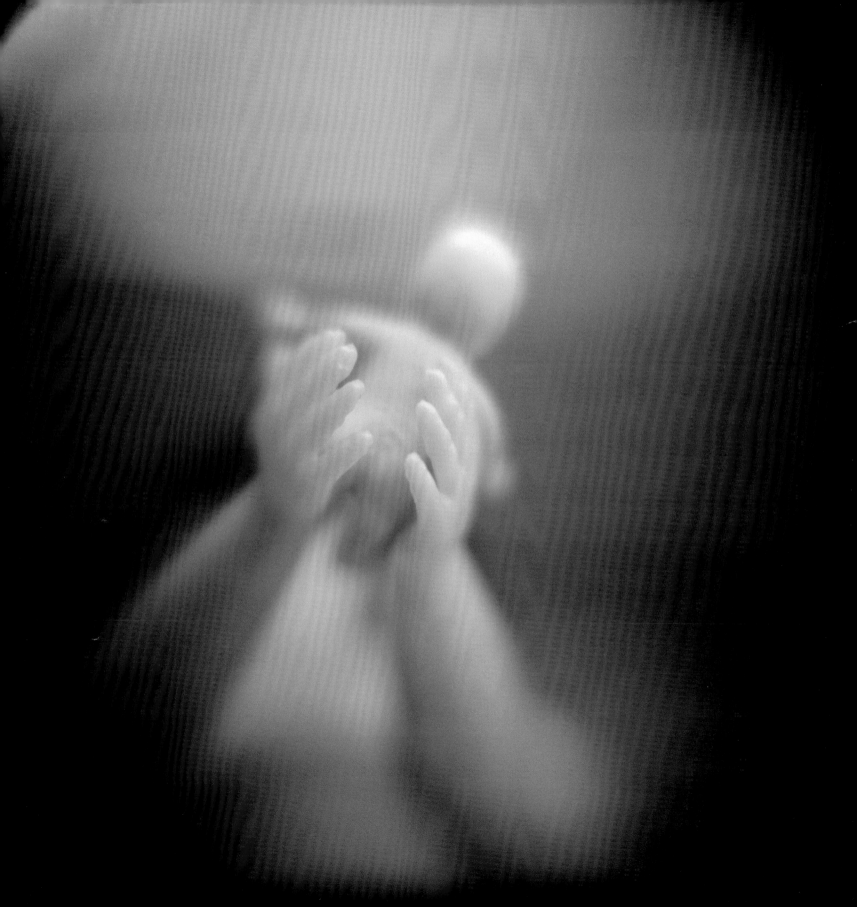

(Frank Relle

In 2004 and early 2005, I photographed the rich cultural story of New Orleans via its architecture, which reflects the personality of its citizens. The houses in their varied styles and states of repair, blended into a whole, reveal a fabric of life in the city more complex than if we looked at them separately. In my work, I juxtaposed images of ramshackle shotguns and grand mansions with the intent of depicting them in the same light.

After the levees broke, New Orleans turned pitch black. Although the complete darkness surrounding the flooded homes was intimidating, it forced me to work differently. I had to bring more of my own lights and power to the shoots, and in doing so a new story emerged—the destruction of the built environment and the culture it represents. Shot at night under these circumstances, the houses revealed the true mood of the city at that time.

I continued photographing the architecture of the city long after the storm. I wanted my images to show that the city was still standing. But I also wanted to explore the issues of preservation, renovation, abandonment and teardowns. Having brought more lights to capture New Orleans after Katrina, I was able to work on larger scenes showing the city's abandonment.

While each house I photograph has something different to show me, one overriding lesson I have learned is to get out there and get the picture, no matter what. If I contemplated photographic concepts before going out into the barricaded Ninth Ward at night, I don't think I would have made these photographs. I never asked for permission. Instead, I asked for forgiveness.

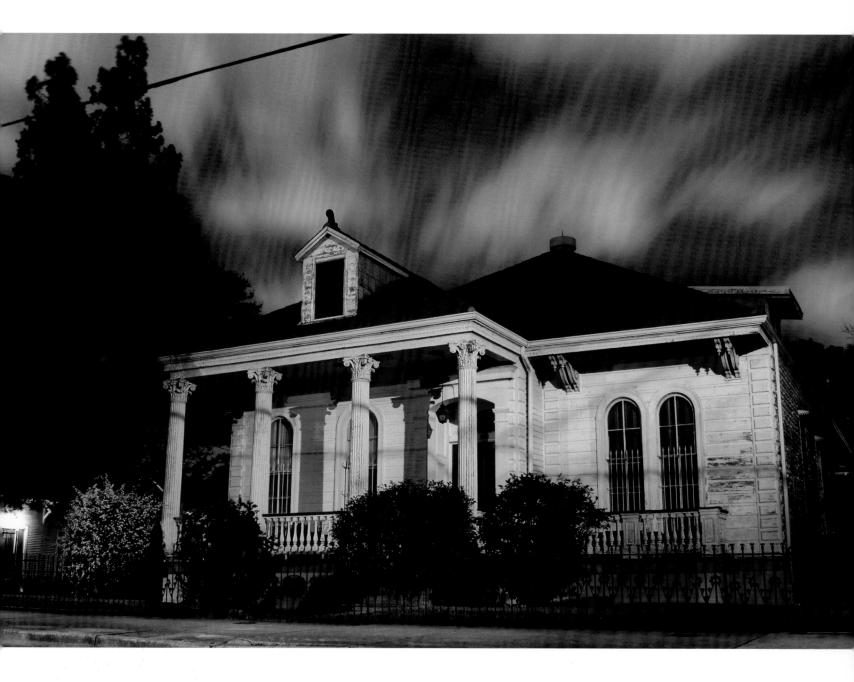

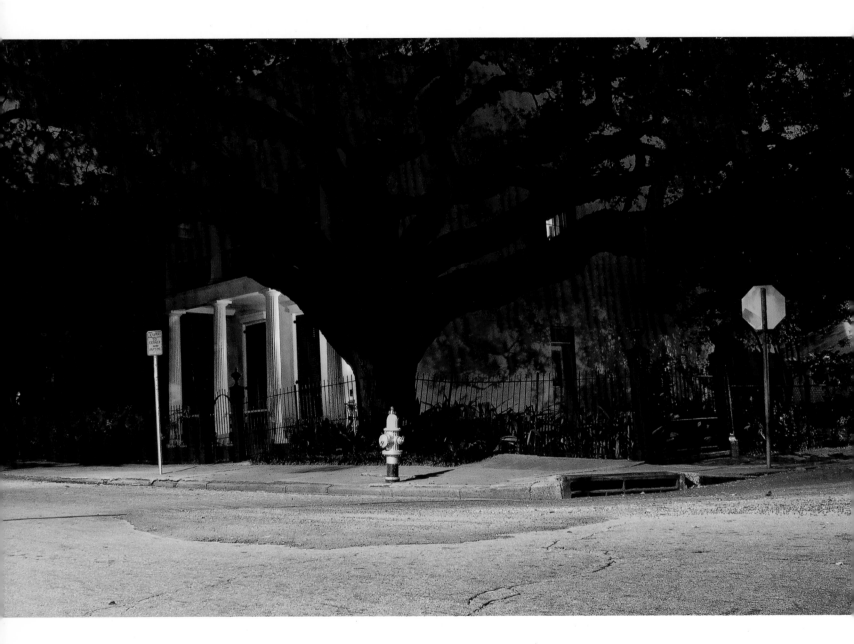

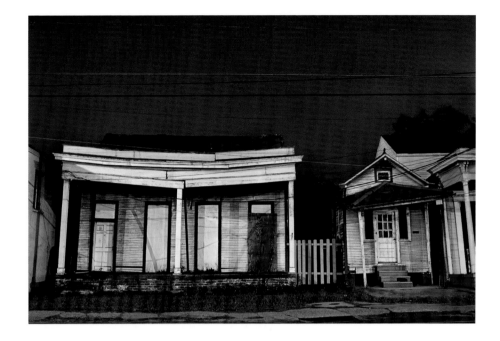

each telling the story of its life

a new story

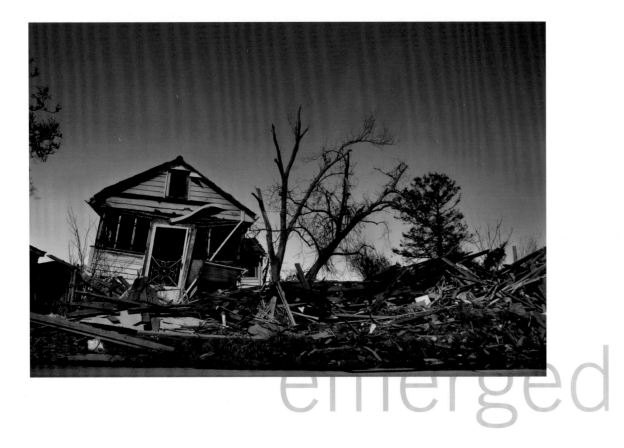

emerged

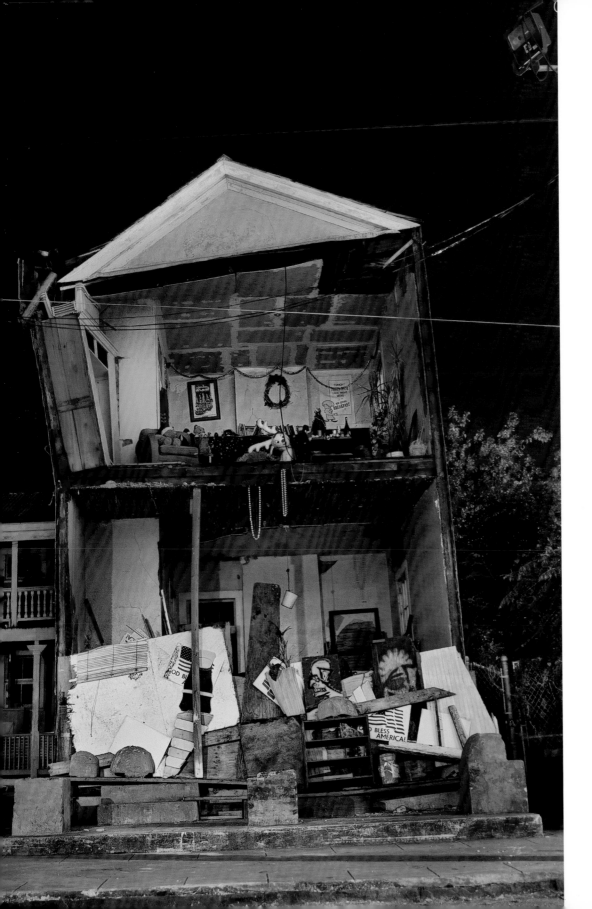

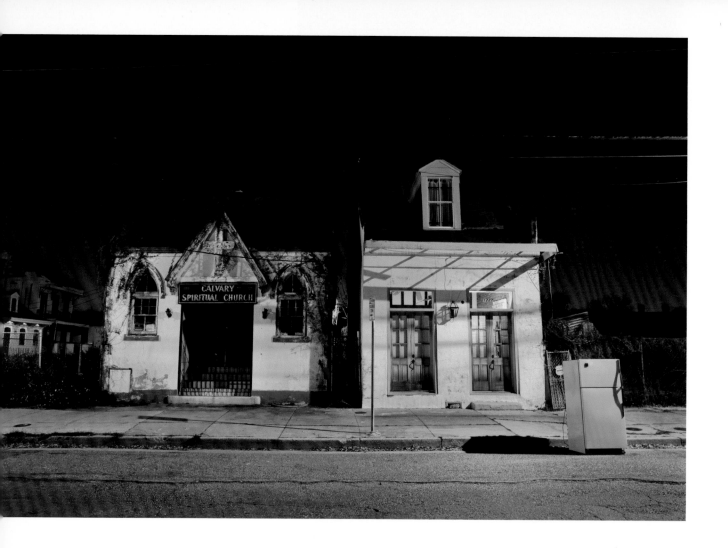

preservation

renovation

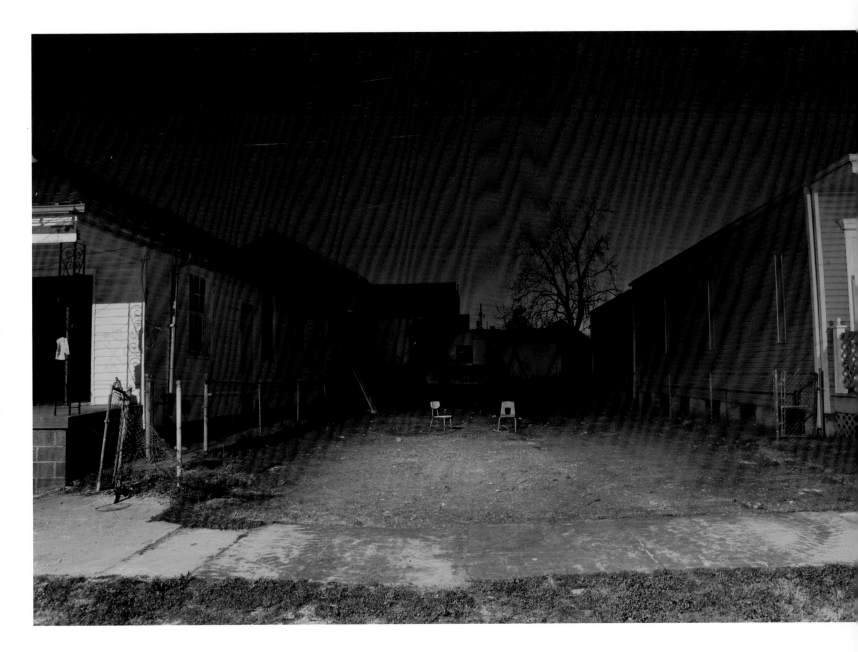

abandonment

I lived in Johannesburg, South Africa for nine years. I began photographing life at night while traveling for my photographic assignment work. I was intrigued by the buzz of people on the streets after sunset, drawn to the patchy street lighting and how that light brushed and defined human movement within the landscape. It was my way of seeing daily life outside of the news stories I was assigned to cover. As the body of work grew, I could see I was creating a portrait of Africa that counters the clichés and documents the vibrant yet ordinary life of African cities.

I left Africa and moved to Baton Rouge nine months before Hurricane Katrina. I continued to work as a freelance photojournalist. For two months following the hurricane, I worked every day for *The New York Times* and *The Los Angeles Times*. I drove continuously up and down the Gulf Coast to photograph the people whose lives and histories had been washed away. Their horror stories were endless, and I began to feel scattered and unhinged. I took a break from freelance work to tell stories that were important to me.

I bought a panoramic camera and began to work on my own; for nine months I photographed New Orleans, which was mostly empty and broken. Instead of using the camera to produce traditional epic landscapes, I used it to study details—debris covering a section of a staircase; a family photograph left behind on a dining room table. The panoramic format enlarged these small details, granting each a respect and consideration I felt they deserved. I made these images with a longing to bring people back to the city.

After the first anniversary of Hurricane Katrina, I wanted to work on a project that took me away from the disaster. My opportunity came when a magazine called *Imagine Louisiana* asked me to photograph the hospice program at Angola State Penitentiary. I used my traditional 35mm camera to cover the story for the magazine, but I also used the panoramic camera for myself. Once the assignment was completed, I received permission to continue photographing the program on my own.

LORI WASELCHUK)

(Lori Waselc

portraits of

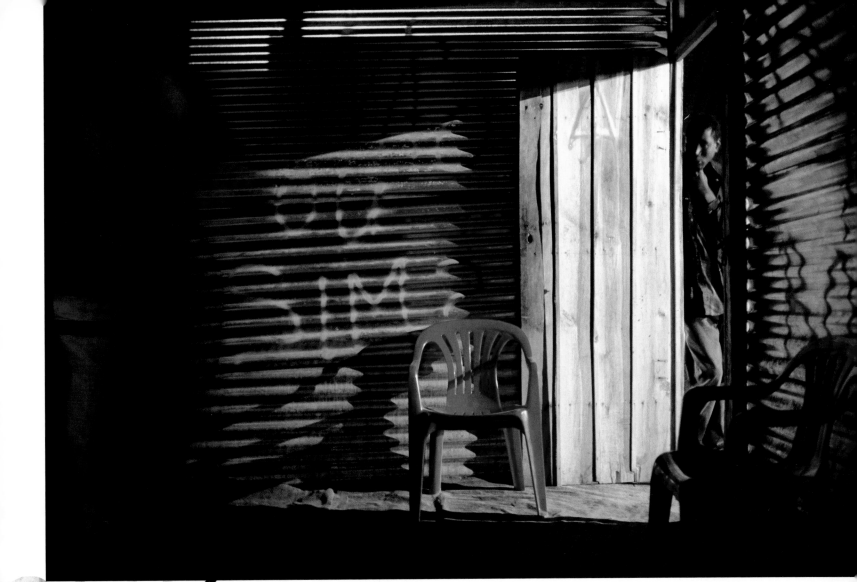

nuk

african nightlife

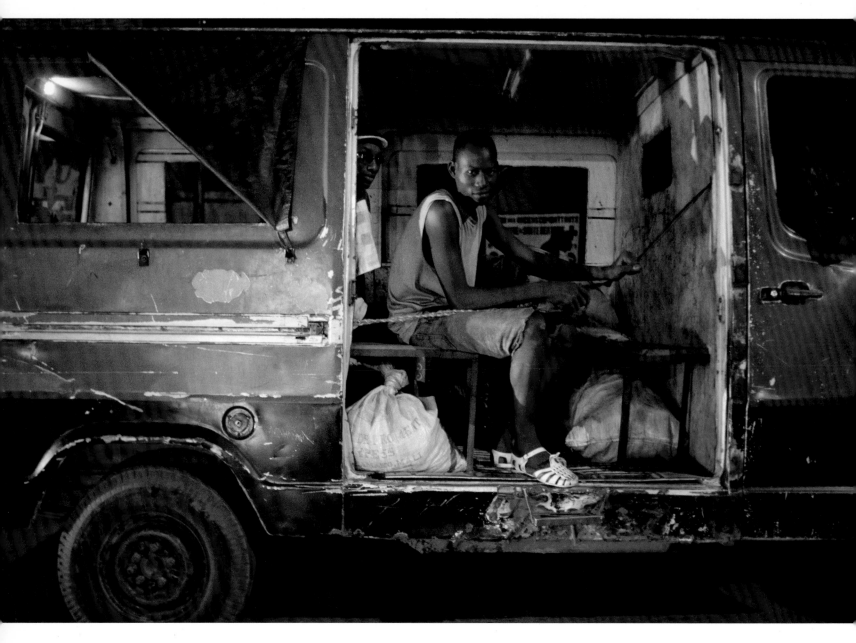

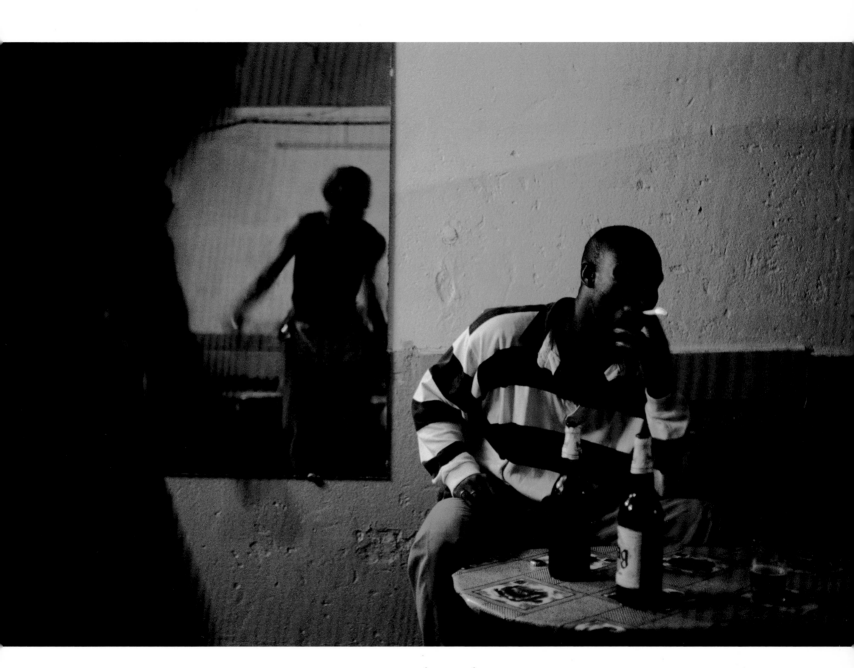

landscape

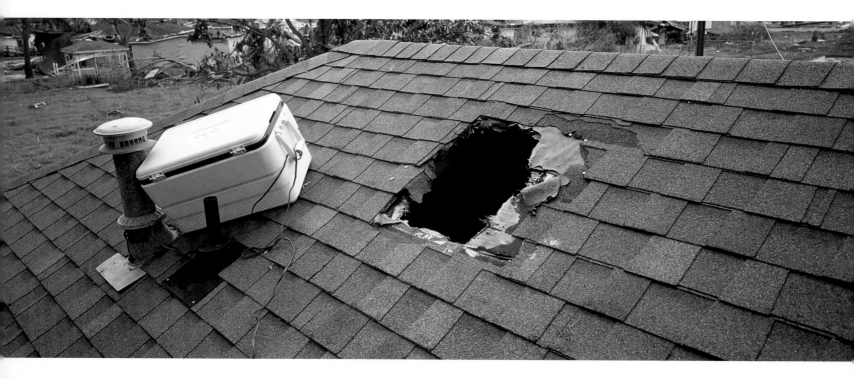

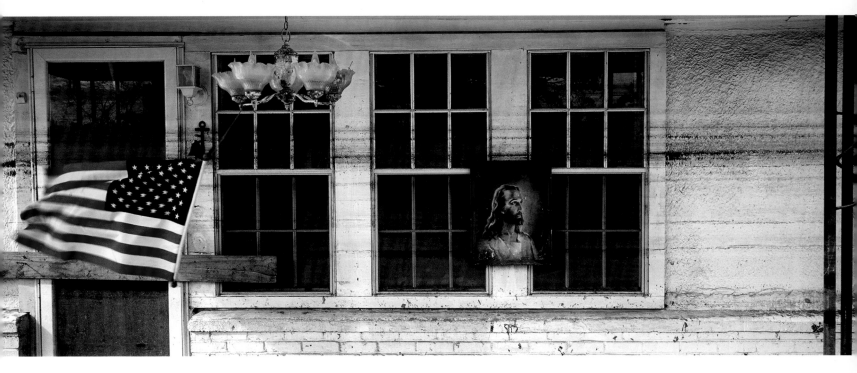

human tragedy

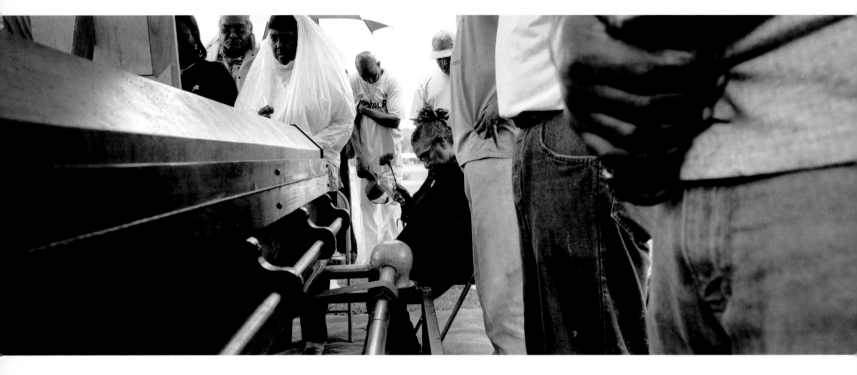

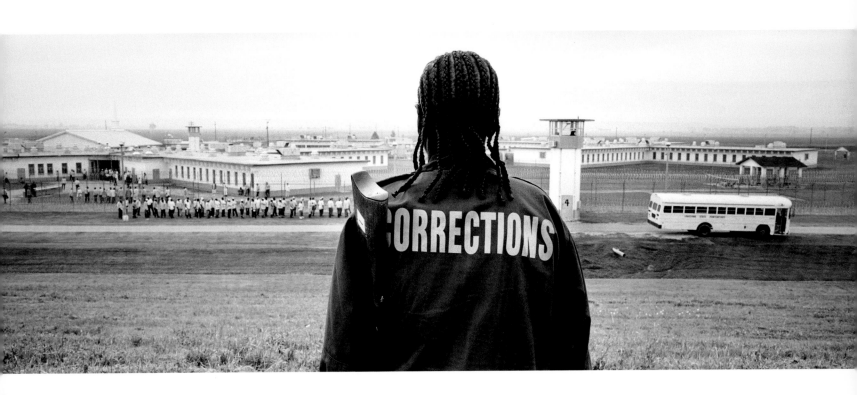

quiet

ROWAN METZNER)

(Rowan Met

Katrina followed me to Italy and revealed herself in my work in unexpected ways.

I had been studying at the Rhode Island School of Design before Katrina and working on a black-and-white photo series of abstract portraits of the body. By re-contextualizing the beauty of the human form and breaking it down into shapes, I was playing with the relationship between a subject and its environment. Sometimes this division between form and background was clear; other times the distinction is ambiguous—blurring the line between body and nothingness.

Then Katrina swept through my hometown, and everything changed. Isolated in Rhode Island, I was in a state of "hallucinated lucidity" and needed to get down to New Orleans to see the destruction for myself. I photographed my dad's house and neighborhood. Immediately I realized how important color was to show the "sur-reality" around me. Where there once was color, now there was only black and white. Photographing with color film (really for the first time), I began paying more attention to details, focusing on people's accumulation—either treasured objects, which were now piles of trash, or solitary items left in unexpected places. I was captured by the randomness of it all.

This new attention to clutter and accumulation, along with an overshadowing doomsday feeling, kept creeping up in my work, even though I was miles away from New Orleans, studying in Rome. The theme of drowning and destruction—either literally or metaphorically—also kept appearing in my images. Color remains an important component in my work. Katrina forced me to look at my life in new ways, and since the flood I have started revealing a more personal story, one that also speaks on a larger human scale.

body

znor

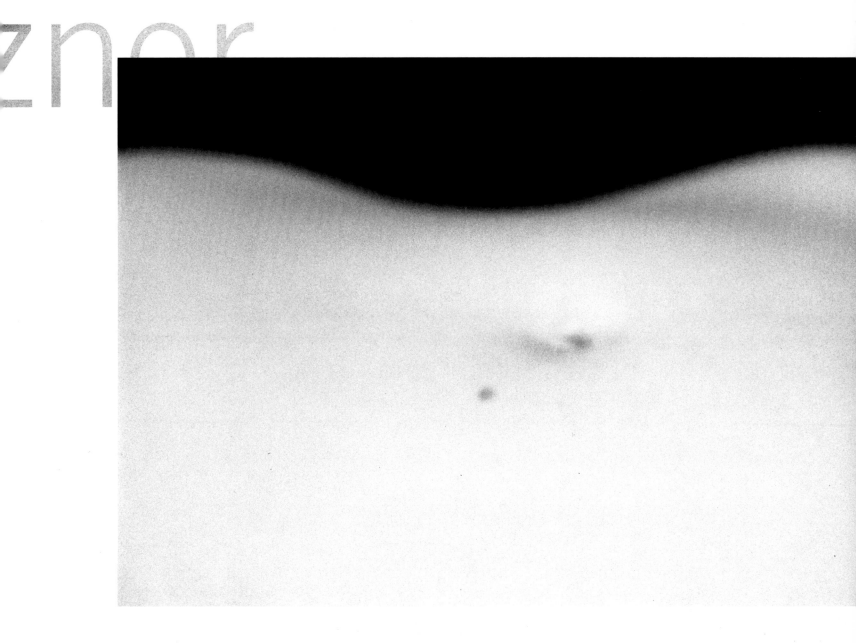

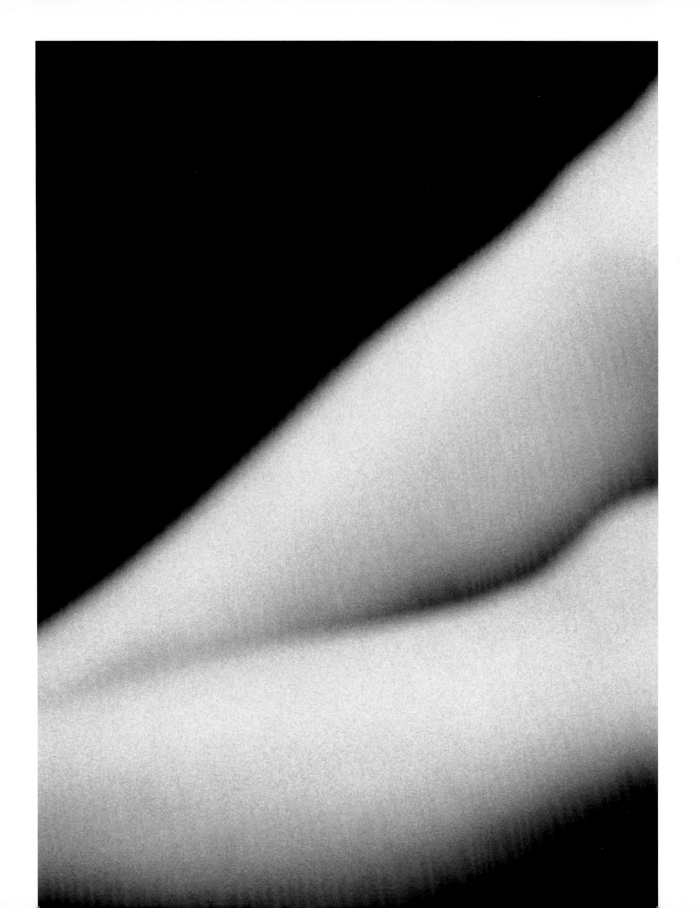

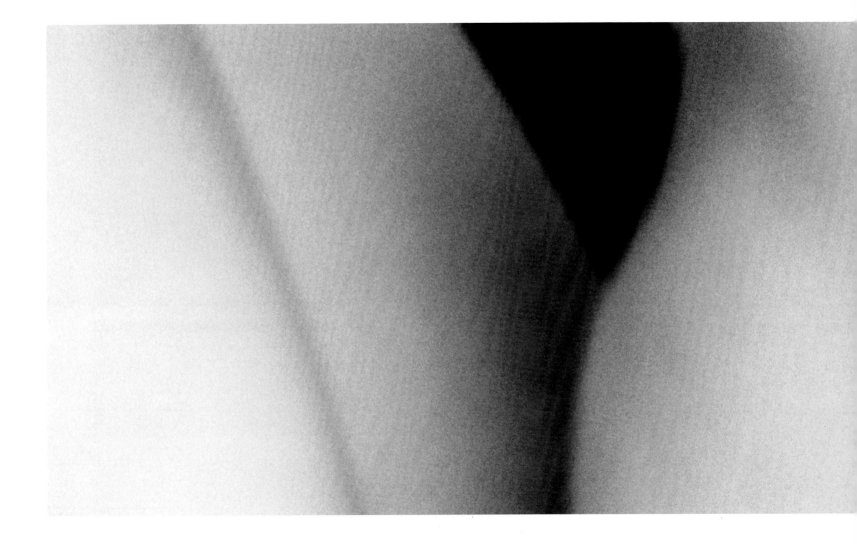

there once was color

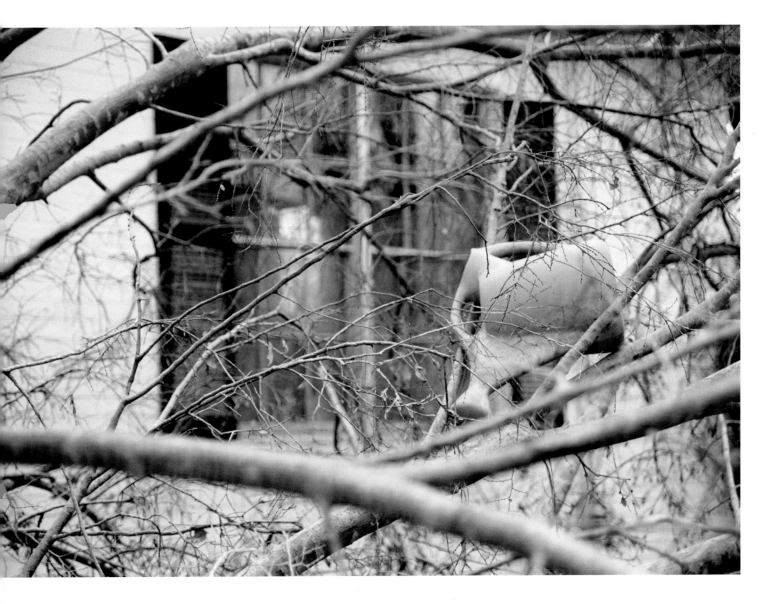

now

doomsday

unconscious shifts

Before Katrina, I was photographing maybe once or twice a week. The subjects varied but consisted mostly of landscapes, textures and light that struck me. I also did some portrait work and the occasional wedding. At that time photography, while a big part of my life, was not as vital to me as it is now.

My wife, daughter, and I were living in St. Bernard Parish when the wind and water flooded our house, submerging my darkroom and equipment under fourteen feet of water. While I managed to take a few cameras with me on our exodus the day before the storm, five long months passed before I made a single photograph.

On each return visit to St. Bernard, I realized more and more that nothing was being done—the damage remained. So I bought some supplies and began photographing every chance I got, posting the images on photo forums on the web and onto my own website. It wasn't long before some wonderful people donated new equipment, including three enlargers, which allowed me to begin printing images again.

Over time I became numb to the post-Katrina landscape. Almost two years after we lost everything to Katrina, my family and I—no longer willing to wait for the Louisiana Road Home funds to come through—used some insurance money and all our savings to buy a new house in Madisonville, Louisiana, twenty feet above sea level.

In this new home and community, I have set up my darkroom and begun photographing my new surroundings. I've found an unexpected motivation in the local fishing community and have enjoyed exploring the shores of Lake Pontchartrain. Water and nature have once again become central themes in my imagery, however, I use the flexibility of 4x5. I am revealing a more ominous scene than I did through my work before Katrina.

SAMUEL PORTERA)

(Samuel Po

tera

light

textures

the subjects varied

nothing

was being done

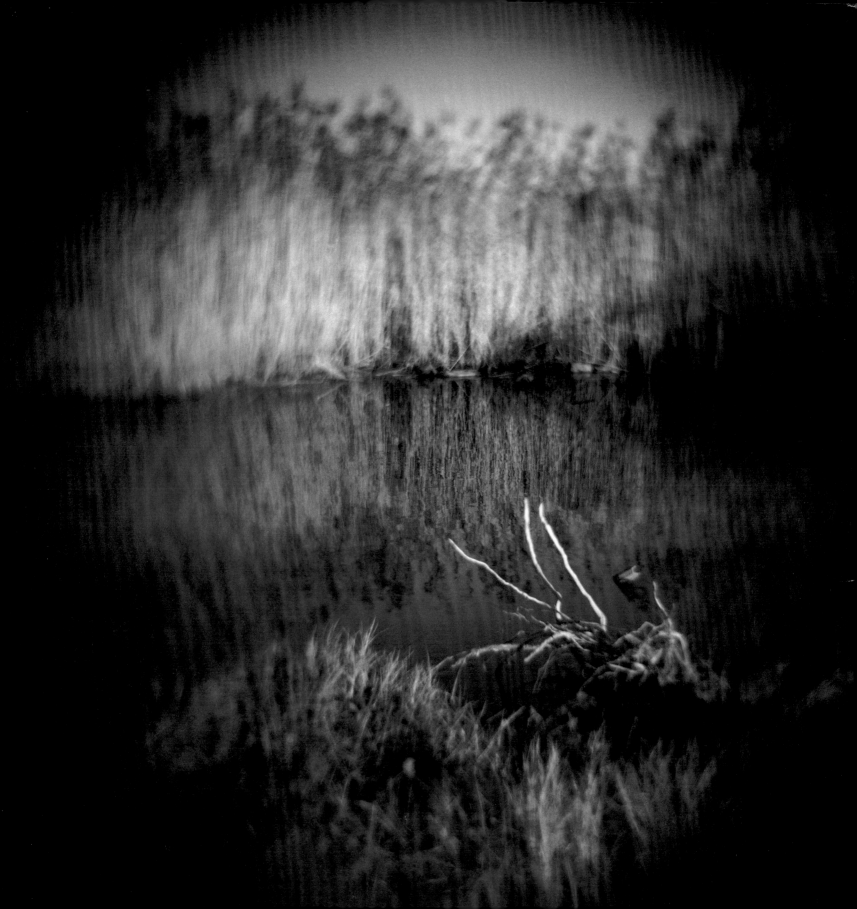

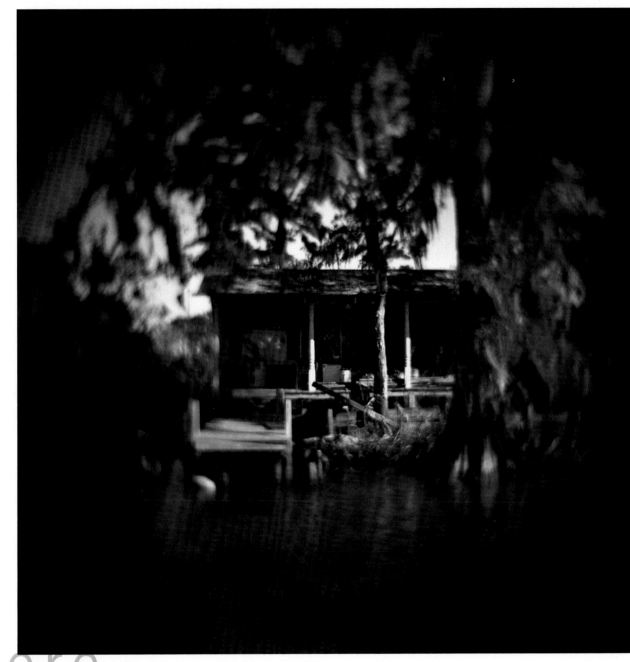

a more ominous scene

(David Rae

After moving to New Orleans on a whim in 1994, I soon found that with its rich and dynamic culture, the city was a photographer's dream.

I quickly established myself as a photographer, working for a host of local, national, and international clients, newspapers and magazines, as well as on my own personal projects. I even did a book on Mississippi with my father, Willie Morris. I bought a house, had a daughter. Life was good.

But by the summer of 2005, I was in a rut, not knowing where I wanted to go with my work. After evacuating with my family to Jackson, Mississippi a few days before Katrina made landfall, the realities of the storm and flood became evident. I knew I had to return to New Orleans to cover the story.

The only way for me to make sense of what had happened was to throw myself into my work. For the next two years I did little else but photograph the aftermath of the storm. There were assignments, exhibits, lectures, and magazine covers. Finally I reached a point where I could no longer engage Katrina on any level. But there was no place to hide. Katrina was everywhere; it permeated our daily lives, affecting every aspect of our routine and overwhelming our senses.

In the summer of 2007, my partner of twenty years had had enough. Tired of the recovery efforts, the trash, the crime, the finger pointing and the failed politics, she accepted a job at a prominent state university, took our then five-year-old daughter and moved to a small town in southeast Ohio. While I was still haunted and obsessed by Katrina, I lingered another six months before joining her. I decided it was time to take a break from New Orleans altogether, to teach and to re-evaluate my life and career.

Almost five years after the storm, I am constantly asking myself where I should go from here. How can I move on after being a witness to such suffering and such incompetence? What kind of projects do I commit to after working on the greatest story of my lifetime and certainly the story of the century? The answers are slow in coming. Still, I can't completely let go of the city. I remain a legal resident of Louisiana and return every few months. Recently, I came back to watch Super Bowl XLIV at Vaughan's Lounge, my neighborhood bar, to photograph and be a part of the Who Dat Nation. When the Saints won, it gave us all some hope. While the struggle to re-build continues, we could stop for a fleeting moment and celebrate. In the meantime, I try to keep busy as best I can, always searching for direction. While I spend more time in Ohio now, I know what it means to miss New Orleans.

Morris

a photographer's

dream

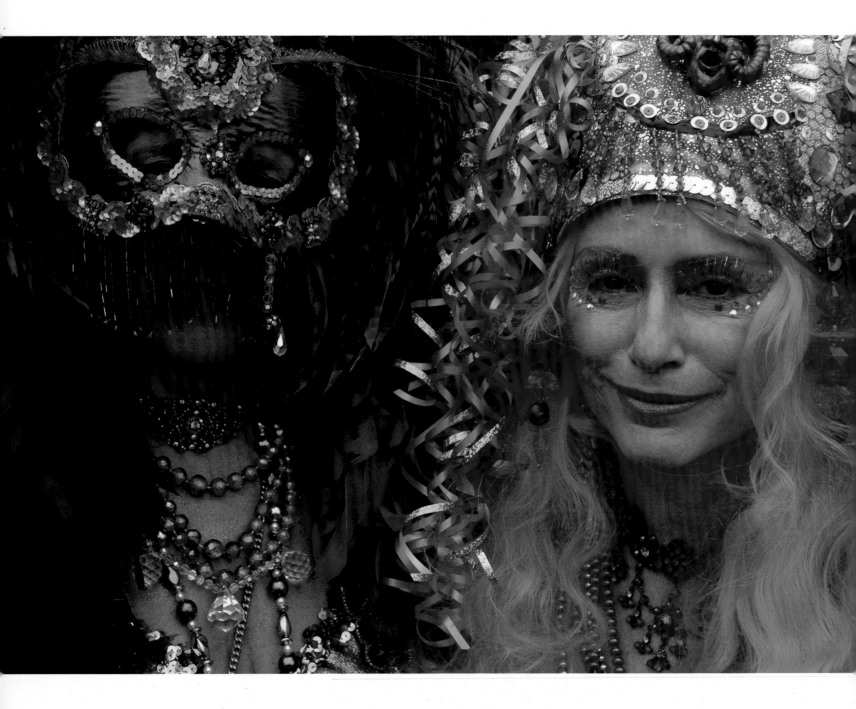

life was

permeated our lives

overwhelmed our senses

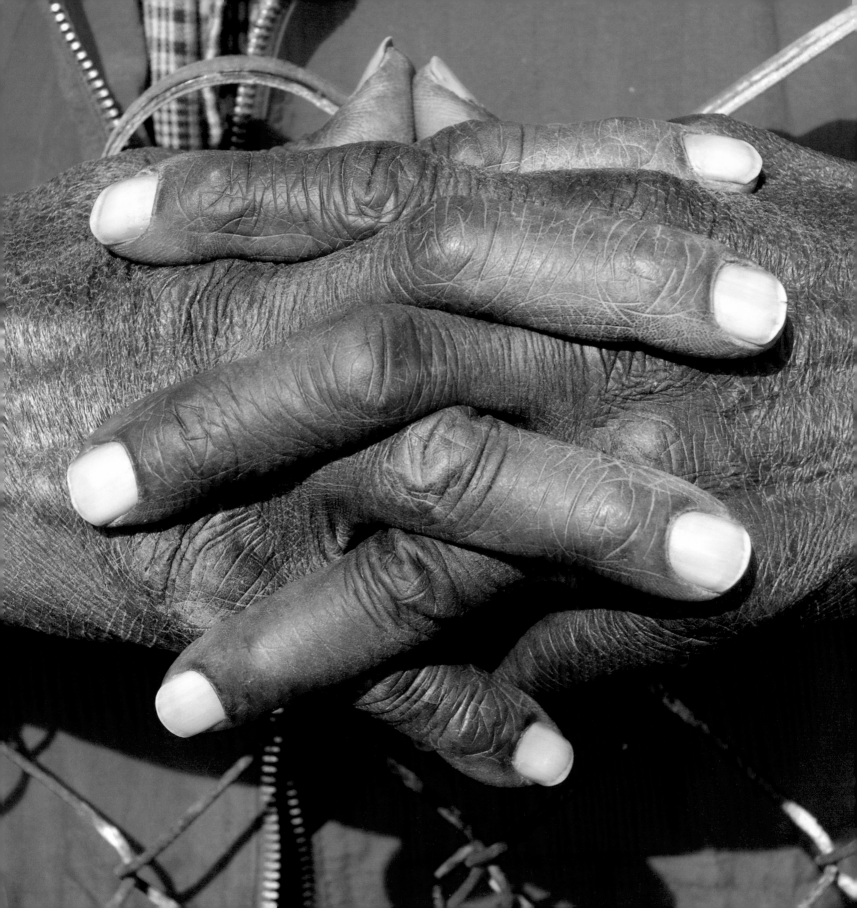

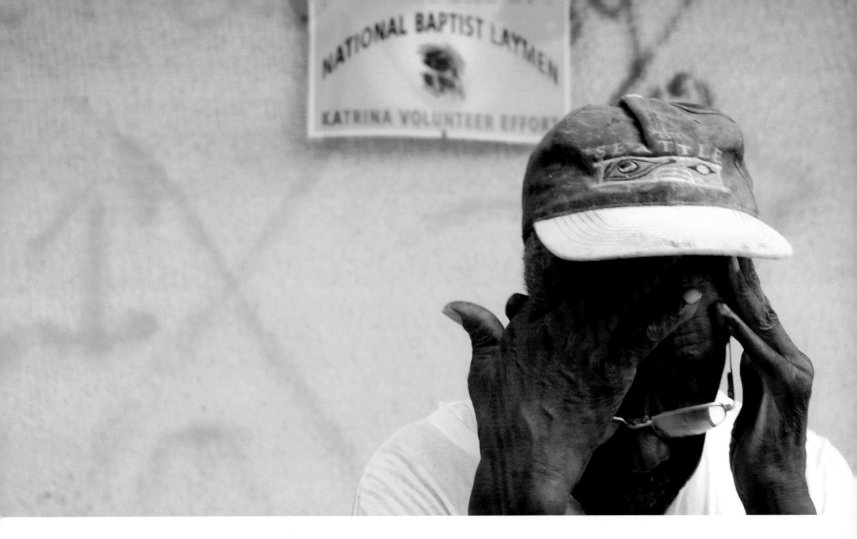

searching for direction

In the years preceding Katrina, I had worked on a variety of photography projects, one of which was a black-and-white environmental portrait series. Shooting on film with an old Rolleiflex, I was attempting to marry the subject with his/her immediate environment. There is nothing overtly New Orleanian about these portraits, created on locations all over the city, yet a subtle abstracted tone emerges. I believe that who these people are is shaped in part by the spaces they know and live around. Likewise, a space, especially a localized or private one, comes alive when inhabited by someone who knows it intimately. It is this intimacy that makes these photographs intriguing.

I was in New Orleans's Mid-City neighborhood for six days during and after Hurricane Katrina. I spent most of that time in chaotic survival mode, but every chance I got I photographed the dark drama and surreal beauty as it unfolded. Assuming the role of the photojournalist helped me maintain my sanity by allowing me to come to grips with the grand trauma, while it was just beginning to register in my heart and mind.

When I was able to return about a month after the flood, I formed an idea for a photo-installation. Upon entering the city, I saw plastic signs on metal tines everywhere—advertising everything from mold removal and hauling services to businesses reopening. Knowing that some of my work was now part of the larger international catalogue of "Katrina" images crowding up the world, I wanted my photographs to have a larger impact. So I printed the photographs I took during the flooding onto those ubiquitous plastic signs and placed each sign in the place where I had photographed the original image. I hoped that being able to witness the "during" and "after" at the same time and place would help the viewer connect to the hardships that went down.

Returning to a damaged city inspired me to work outdoors. Reinvigorating the area with art and photo installations (many sculptural) has been a crucial resolution to the dilemma: How do I continue producing work after such a traumatizing event? A few of the projects were collaborations with Valerie Massimi, under the team name, Victor & Juliet, such as *Help* and *Wooden Island* shown in the *After* section here. While I still make photographs and prints in the traditional way, my focus has strengthened. I have resumed work on my long-term projects with new vitality. The flood taught me that things change, people disappear or move, and life is not as secure as we might want it to be. Working harder on what I love to do is my fight against this disillusionment.

JONATHAN TRAVIESA)

(Jonathan T

shaped by

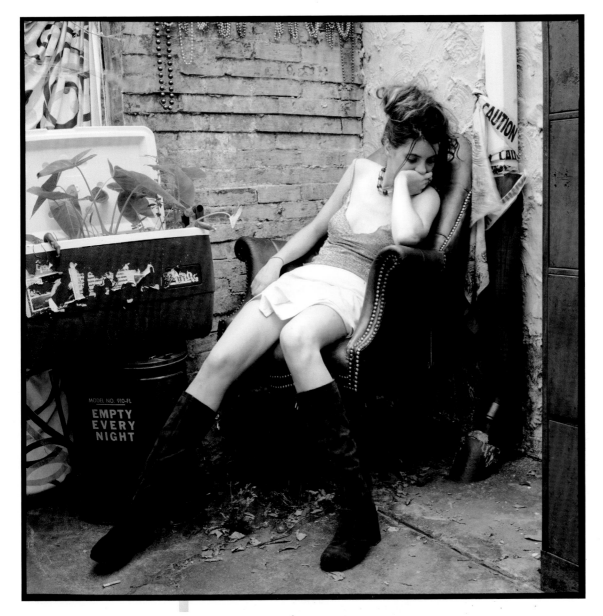

raviesa

the spaces

marry the subject

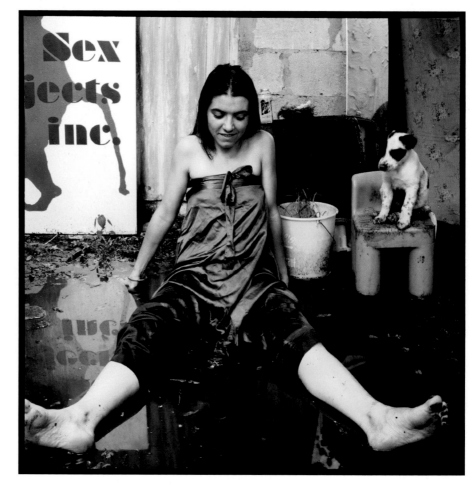

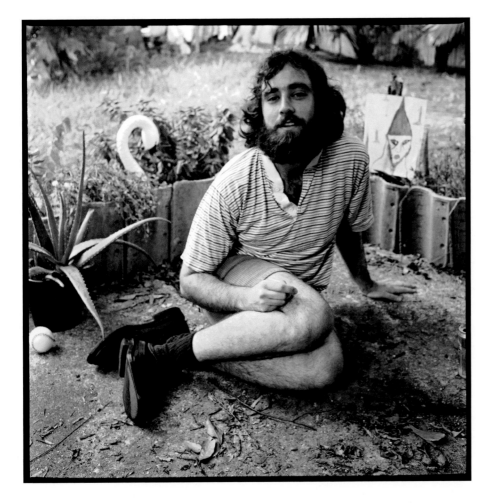

and environment

dark drama

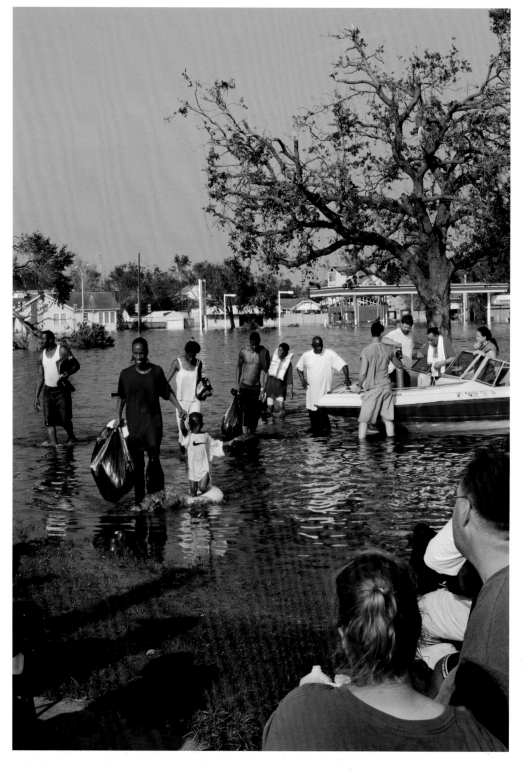

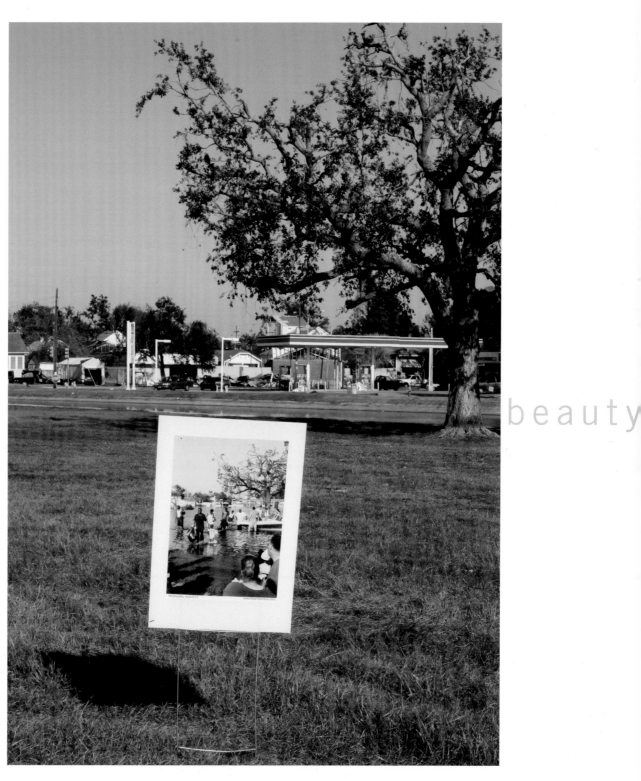

 surreal beauty

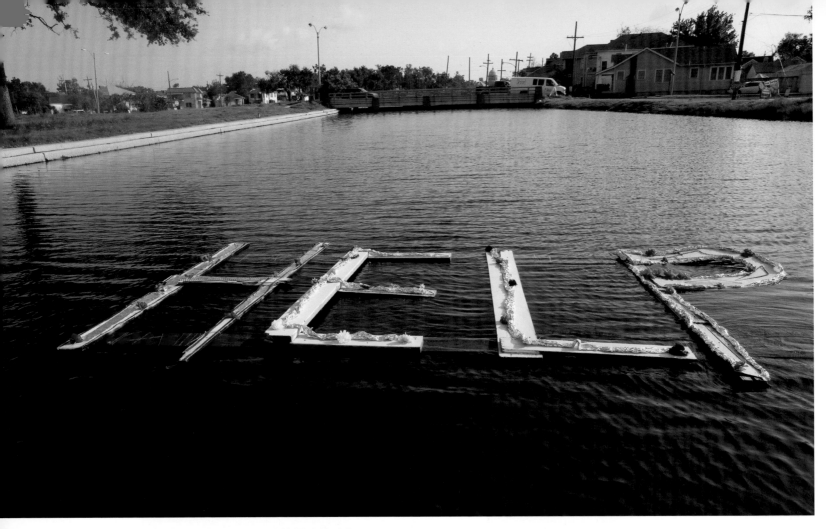

a *Victor & Juliet* collaborative project (with Valerie Massimi)

focus

strengthened

vibrant

common

places

heritage

ERIC JULIEN)

(Eric Julien

Before Hurricane Katrina, I focused my photography on documenting New Orleans and Haiti. Both are vibrant places, formed by the cultural influences of the French and the West Africans. Through my photography, I tried to portray their common heritage.

On the day of Hurricane Katrina, my partner, two-year-old son and I packed one bag for what we thought would be a three-day vacation three hours northwest of New Orleans in New Roads, Louisiana. The next day we woke to discover that the hurricane had blown through New Orleans leaving tremendous wind damage. I assumed this meant that we could drive home to do some serious cleaning and resume our lives. Anxious to get back to the city, I drove briskly, maneuvering through thousands of acres of sugarcane fields, listening to reports of the damage. Each report became more and more troubling. As we

snaked around the winding river roads, I began to feel like a mouse trapped in a snake's intestines. Then the radio reported that the floodwalls had broken and that the water was rising. When I heard the reporters say that we would not be allowed back into the city for at least three to six months, I stopped breathing—seconds seemed like hours.

Although I contemplated sneaking back into the city by boat, the voice of my two-year-old son stopped me. After being cast out by the waters, I began to wander aimlessly around the country. Since I had left New Orleans without my photography equipment, as we traveled I began creating mixed media collages with the few photographs I had or could reproduce. In the end, I lost ten years of work, and while the discovery of mixed media collage has been therapeutic, my work will never be the same.

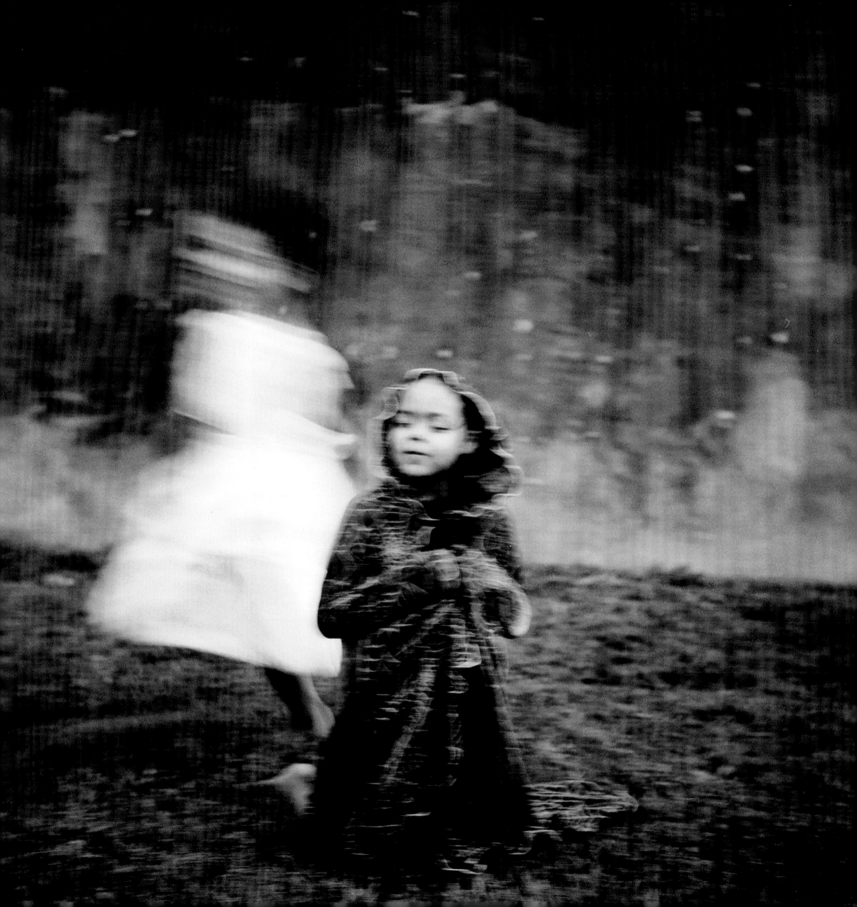

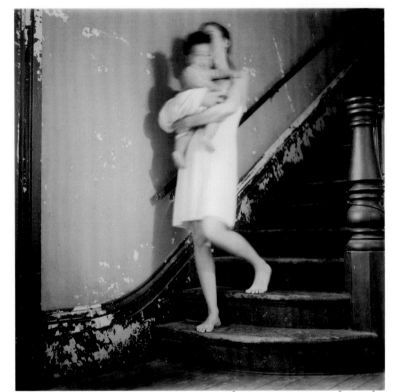

cultural influences

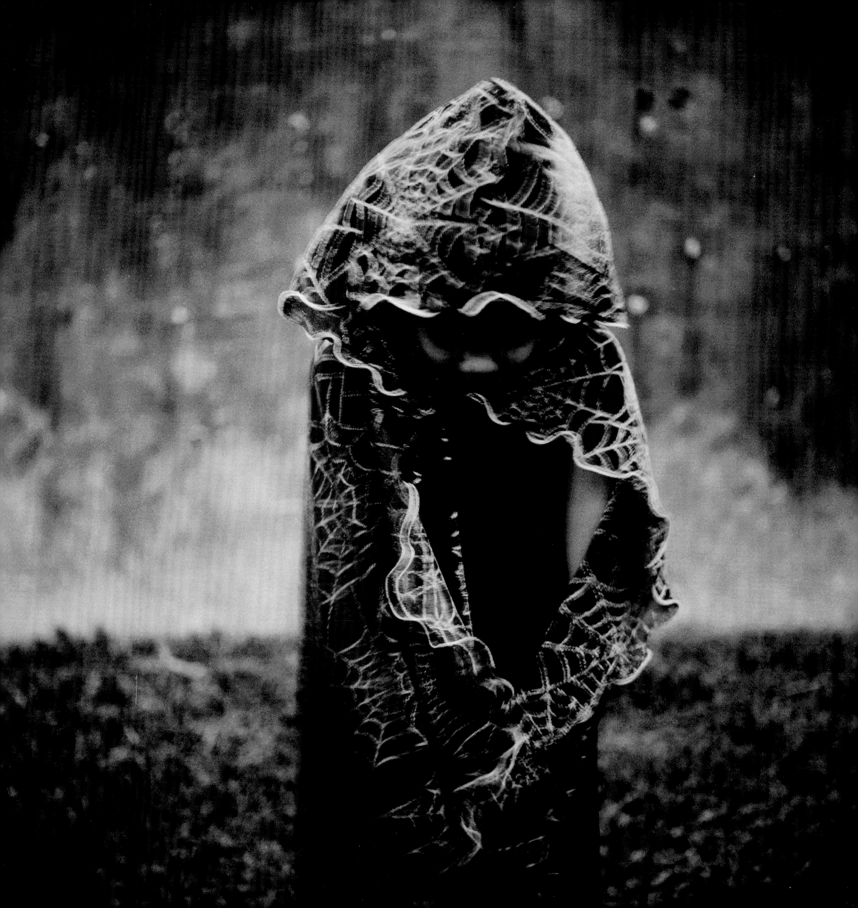

wander

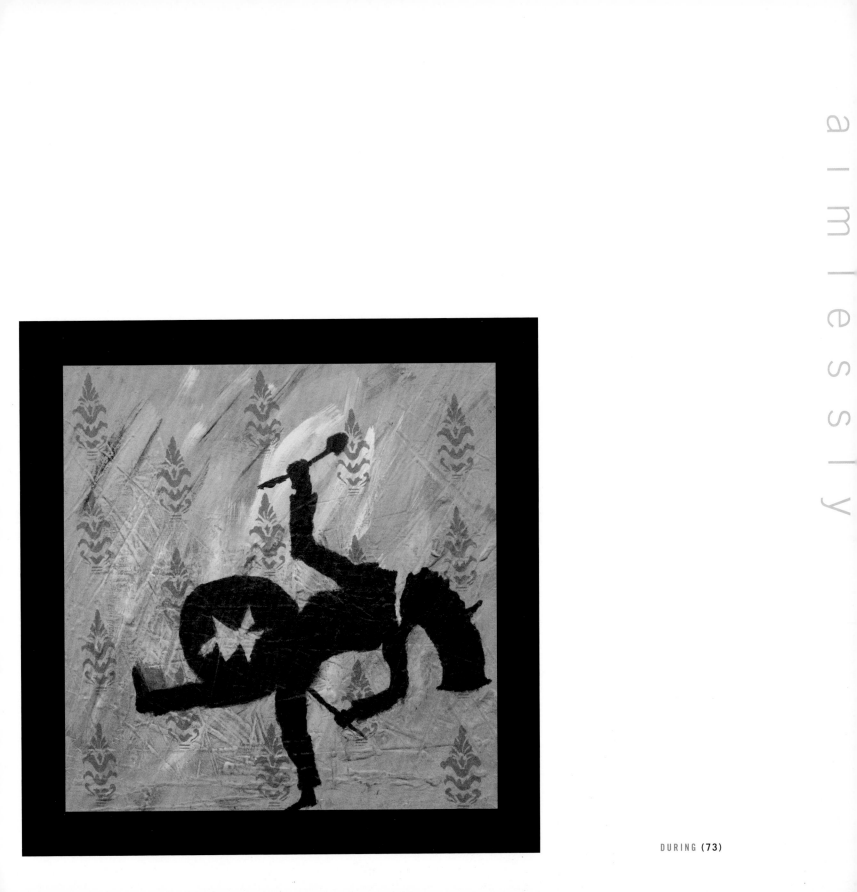

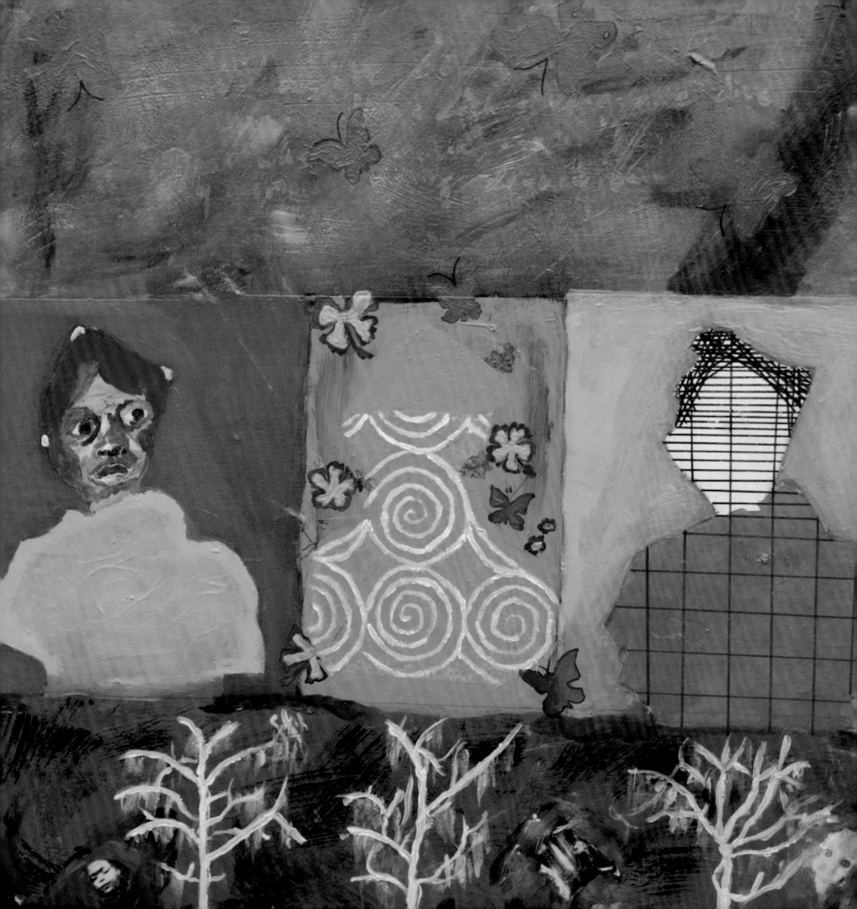

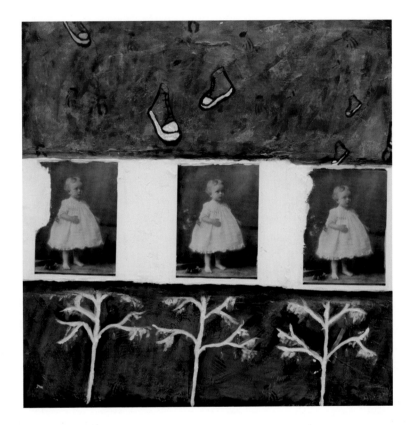

will never be the same

In the years before Katrina, I hustled non-stop, working sixteen-hour days. I was shooting, editing, and creating opportunities in the city where I was going to make a name for myself. In addition to working as the house photographer for Tipitina's, as well as chief photo archivist at the Contemporary Arts Center, and teaching photography at the New Orleans Academy of Fine Art, I was also an assistant to famed jazz photographer Herman Leonard. During this busy time, I began moving in the direction of fine art portraiture, photographing many of the local musicians. I was bursting with energy. Things were happening.

After that fateful Katrina weekend, my clients scattered around the country, and the world I had created for myself was gone. All I could think about was getting back to the city I loved. I managed to sneak into New Orleans and started living off generators and dodging National Guard Humvees. I began my own tree-removal company. Next thing I knew, I was 40 feet up in a tree with a power saw—saving the day, making a living and almost getting myself killed a few times. Sick of the repeated images of devastation in the media, I cross-processed my photographs to create something new. Instead of focusing on Katrina's obvious destruction, I opted to photograph people's response to it through the mountains of debris on the neutral grounds and yard art.

As the months passed, I witnessed the return of people to the city. On a whim, I created backyard portrait sessions—photographing strangers and friends. Along with my continued work with the great musicians who hire me for my particular style of photography, my current art has concentrated on character studies and intimate portraits of the New Orleanians around me. It's only fitting that as my city has changed, so have I. Now I have slowed down, and I take more time to explore my subjects because I realize life can change in a second. I want to make sure the emotion is honest and present and that I am too.

ZACK SMITH)

(Zack Smith

things were happening

shooting

local musicians

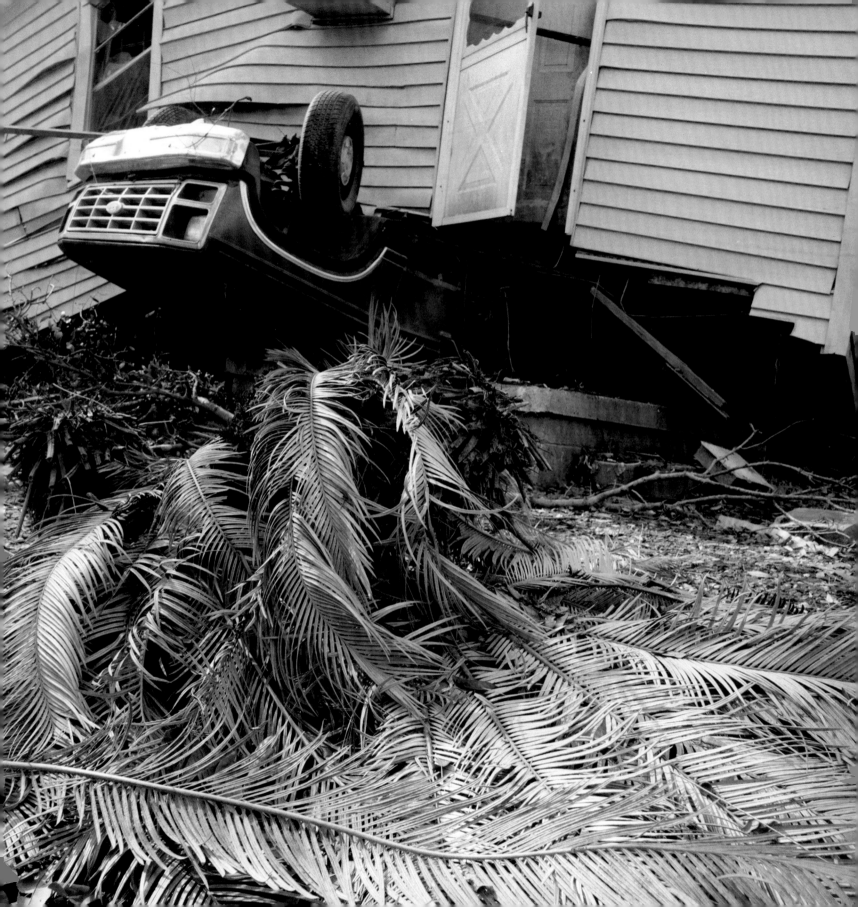

my world was

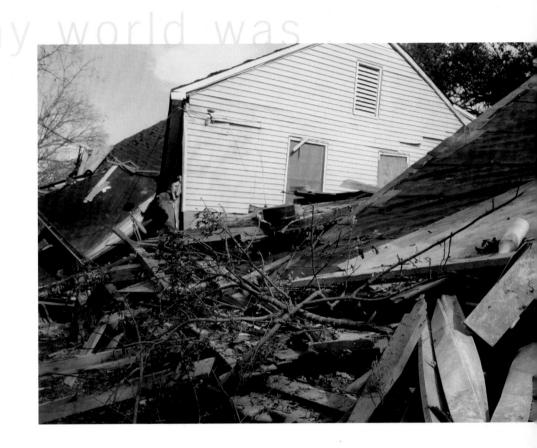

gone

taking time to explore

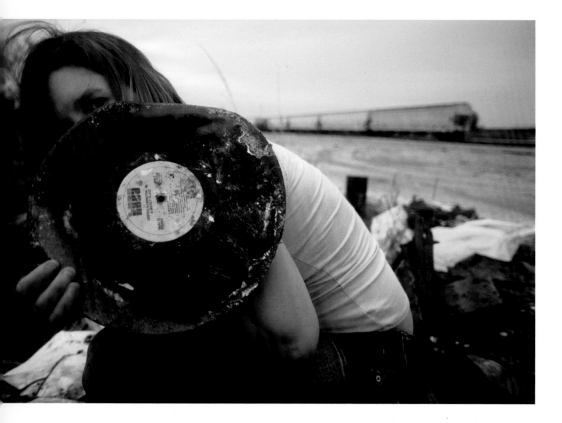

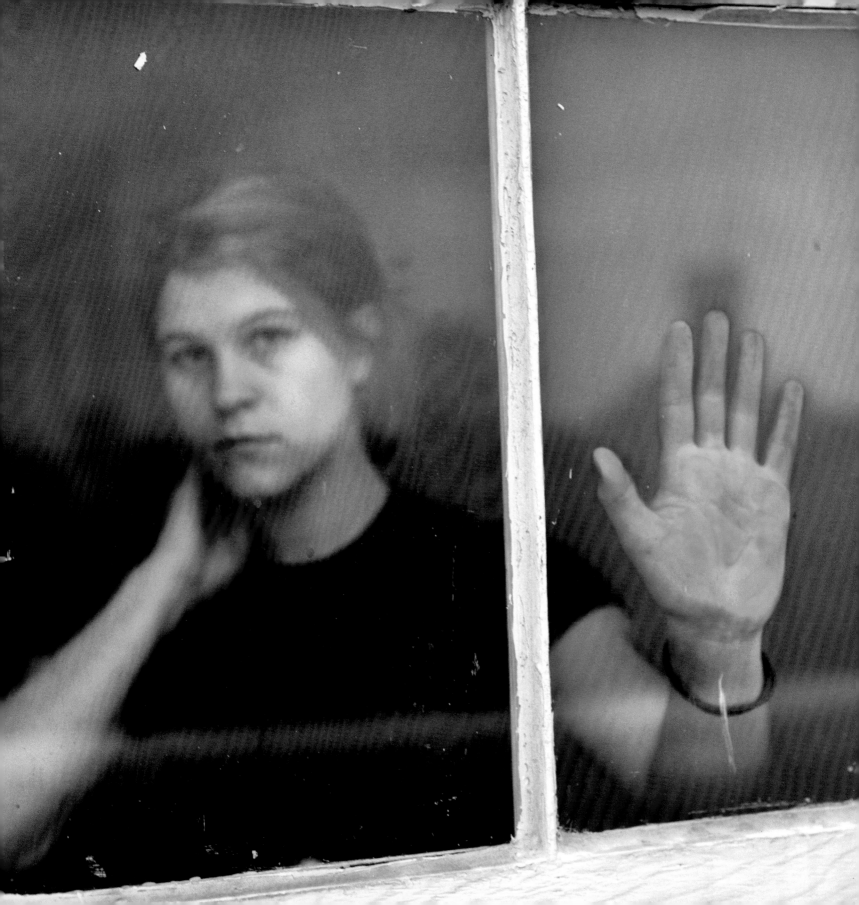

(Elizabeth K

I was never much into photography before Katrina. Instead, I was experimenting with color and texture—working with paint on canvas, art-to-wear jewelry, wooden totem poles, and found objects. In 1993, I moved to the Netherlands where I was influenced by the COBRA movement that had been popular in the Benelux and Scandinavia in the '50s and promoted the total freedom of color and form.

I was visiting my family in New Orleans when Hurricane Katrina grew in the Gulf of Mexico and headed toward my hometown. Like thousands of others, I evacuated the city with my family. Soon afterwards I returned to my home in Amsterdam.

It wasn't long before I was flying back to New Orleans to see how I could help. As the plane approached the airport, I saw roofs covered with blue tarps everywhere; when I got uptown, refrigerators with cryptic messages lined the streets. I knew then that words alone would not adequately capture the devastation wrought to the city, so the day after I arrived I bought a new digital camera. Little did I know

that purchase would re-ignite my passion for art, and that I'd develop a new love interest—photography.

In the year after Katrina, I traveled from Amsterdam to New Orleans six times, each time documenting what I saw. Indeed, photographing the devastation became an obsession—I felt compelled to capture nearly every affront I saw. In the beginning I used a wide-angle lens, shooting the debris against the bluest of skies, which had a haunting, beautiful quality. Later I became more interested in capturing macro shots of the destruction or in singling in on one item, which in some way began to represent the whole awful thing to me. Looking back at my images of this time, I have noticed the recurring element of reflections.

That interest in close-up photography continues, but now I'm photographing exotic flowers and using a variety of techniques to give them a painterly and abstract quality. I am also using reflections in water to create my imagery, although my focus has once again turned to the use of vibrant colors and the "joie de vivre" that we New Orleanians are known for.

with color and

texture

einveld

experimenting

mixed media

total freedom

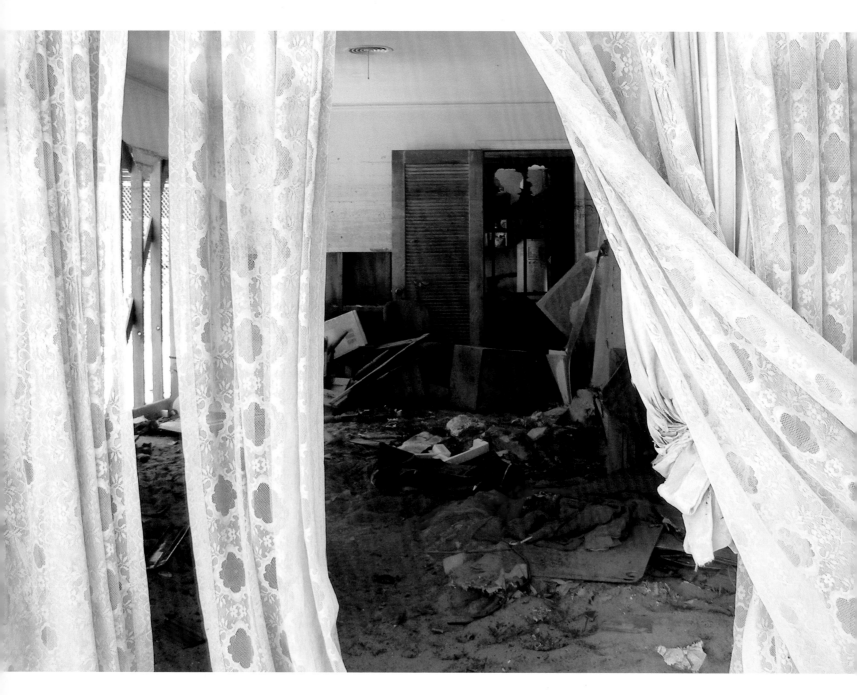

a new love interest

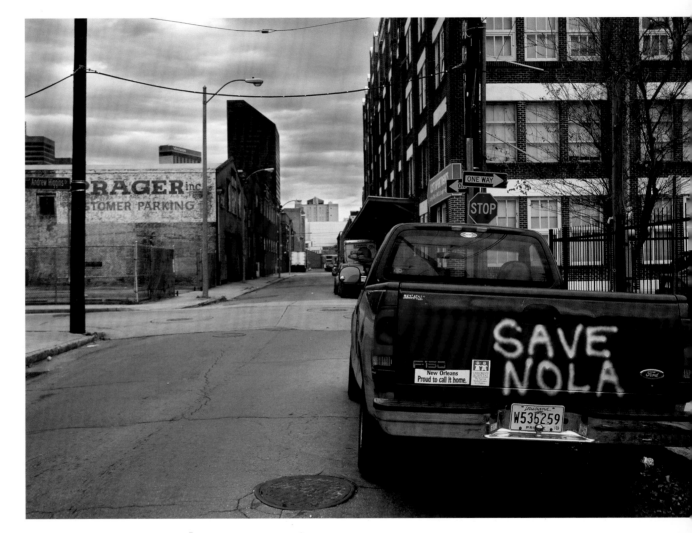

photography

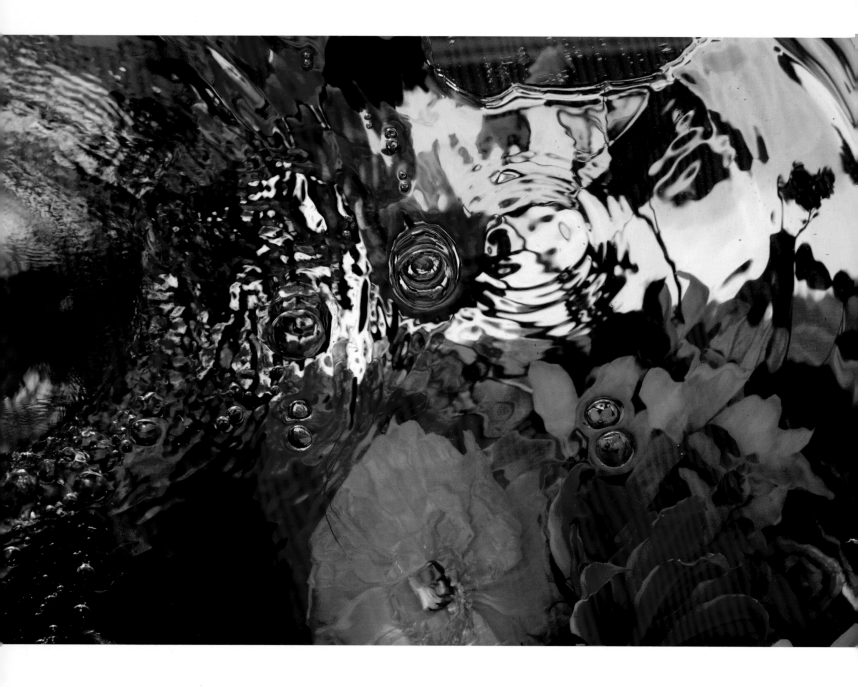

celebrating

being alive

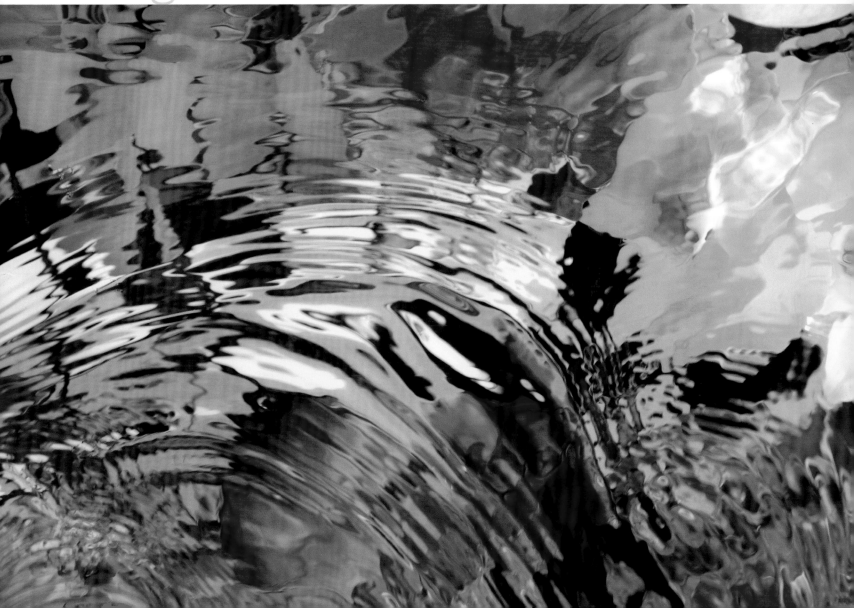

In 2003, after years of community television work in New Orleans, I returned to photography full time. I found a staff position with the Louisiana Office of Tourism, relocated to Baton Rouge and began traveling the state to photograph the natural and built landscape, as well as the living cultural traditions that make Louisiana unique. Then, in January of 2005—just eight months before Hurricane Katrina slammed into the Gulf Coast—I transferred to the Louisiana State Museum's headquarters in New Orleans and moved back home.

On the eve of Katrina's landfall, I evacuated a disabled friend and her pets to Hammond, Louisiana. A week later, as one of the fortunate few, whose neighborhood didn't flood, I returned to my house, using this as a base to document the massive destruction left in the storm's wake. Initially, I focused on New Orleans but soon began to photograph other heavily damaged areas lying to the south and east of the city. When Hurricane Rita struck Louisiana on September 24th, it continued where Katrina had left off, devastating the westerly portions of the coastline that had escaped its predecessor. I expanded my coverage to include these areas, too, which meant crisscrossing a 300-mile swath that extended from Louisiana's eastern border with Mississippi to its western border with Texas.

The scale and ferocity of damage caused by the two storms were overwhelming. By concentrating on the aesthetics and mechanics of making images, I tried to insulate myself emotionally, but I had too many memories and ties connecting me with the places I was photographing. By May of 2006, I recognized that I was at the breaking point and had to get away, far away. I chose South America—a new destination for me—where I found solace and renewal by hiking among towering peaks, visiting cities that bustled with activity, and exploring a different culture and visual palette.

After six weeks of travel through Bolivia and Argentina, I flew back to New Orleans to resume work, shifting my attention to the city's recovery efforts. As numerous buildings became slated for demolition, I often found myself engaged in "visual salvage" operations, racing to document poignant vestiges of pre-Katrina life before they succumbed to the wrecking ball.

Emerging from these experiences, I began to reflect on the importance of photography in our collective memory. Prior to Katrina, documentary photographers had concentrated on recording public rituals and celebrations, while neglecting to cover ordinary aspects of daily life. Coupled with the destruction of untold numbers of images by hurricane winds and water, this lapse has created major gaps in the visual records of our local communities. We can't recapture the past or replace our missing photographs, but as we move forward with rebuilding, it's vital to safeguard the images that we do have and commit ourselves to creating a more balanced and inclusive visual archive.

MARK J. SINDLER)

(Mark J. Si

living

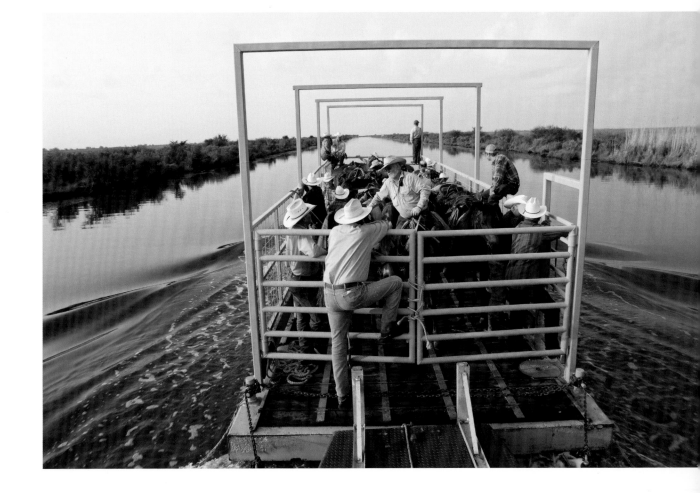

ndler

cultural traditions

the natural

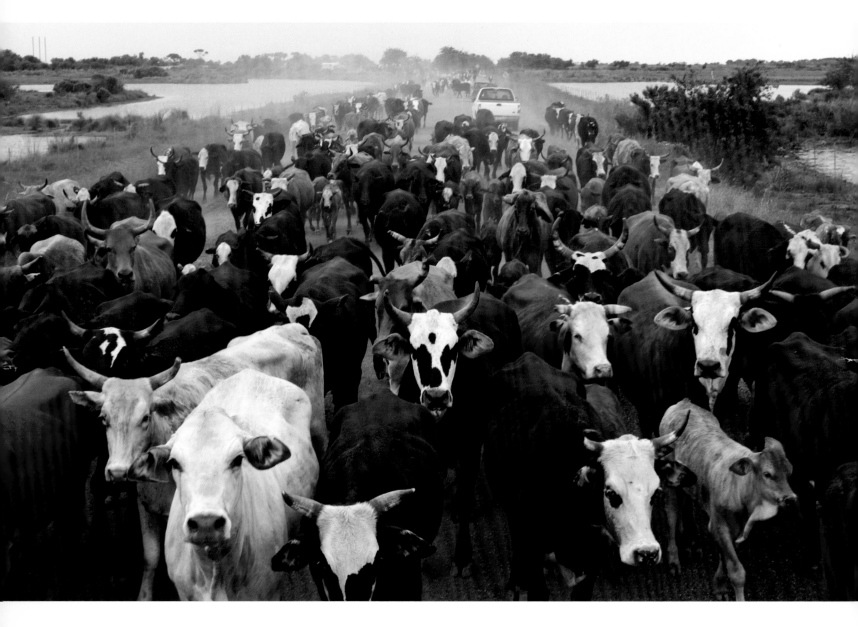

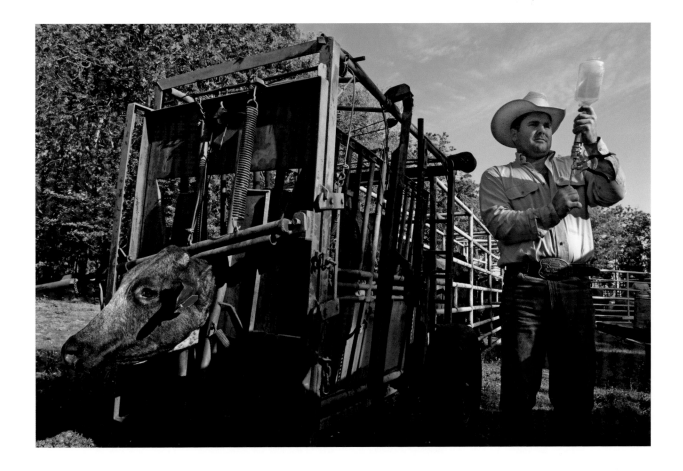

_document the massive

destruction

photography in collective memory

(Thomas N

Two decades before the events of Katrina unfolded, a major theme of my work was documenting the rapidly disappearing single-family farms and ranches in Colorado. Even after moving to Louisiana in 1982, I continued to compose new photographs of these ranchers. During these visits, our conversations were often about scratching a living from the land in the face of pressures from agribusiness conglomerates. Their stories became increasingly gripping, so in time, written narratives began to accompany many of the images. My influence came from the seminal work of James Agee and Walker Evans, who in the mid-1930s documented the lives of three tenant farm families in Hale County, Alabama. Their book, *Let Us Now Praise Famous Men* is considered the first endeavor on the part of writer and photographer to offer equal contributions to "complete" a story. I hoped that my efforts would function in the same regard.

In the aftermath of Hurricane Katrina, I once again became both a photographer and writer. For me, the epiphany to photograph "holdouts" came on the first day of a search and rescue operation assisting with the evacuation of New Orleanians who either chose to stay or could not evacuate prior to the onset of Katrina. This endeavor proved to be both a project and a mission that would be the high point in my career. I felt compelled to photograph them, but as I listened to their stories, written narratives began to flow. In 2006, the Ogden Museum of Southern Art mounted an exhibition of the work. Then the University of Missouri

Press published the portraits and narratives in a book titled, *Holding Out and Hanging On: Surviving Hurricane Katrina.*

Throughout the post-Katrina years, I have returned to visit with many of the folks who shared their stories with me. Most have brought some semblance of order back into their lives. Even my perpetually homeless friend, Tommie Elton Mabry, who had written a journal on the walls of his apartment in a housing project, has found permanent shelter. Conversely, six people pictured in the book have died, three of them because of violence. Two others regained their lives after the storm only to suffer severe burns in a fire that destroyed their French Quarter apartment.

In addition to mounting a traveling version of the original Ogden exhibition, I have continued to explore and revisit my previous work and the themes that have shaped my life for the past 40 years—primarily people and place. During weekend sojourns in rural South Louisiana or travel elsewhere, I am drawn to people who are at "home" engaging in the circumstances of their lives. Strangers one and all, they are curious to see my head go under a dark cloth to set the composition on the ground glass. Once I close the lens and insert a film holder, I stand next to the camera quietly conversing with the subject. Whether it comes from a kindness we share or the moment that seems inexplicably right, in releasing the shutter I hope to capture imagery that encompasses what we all hold dear—affection for life.

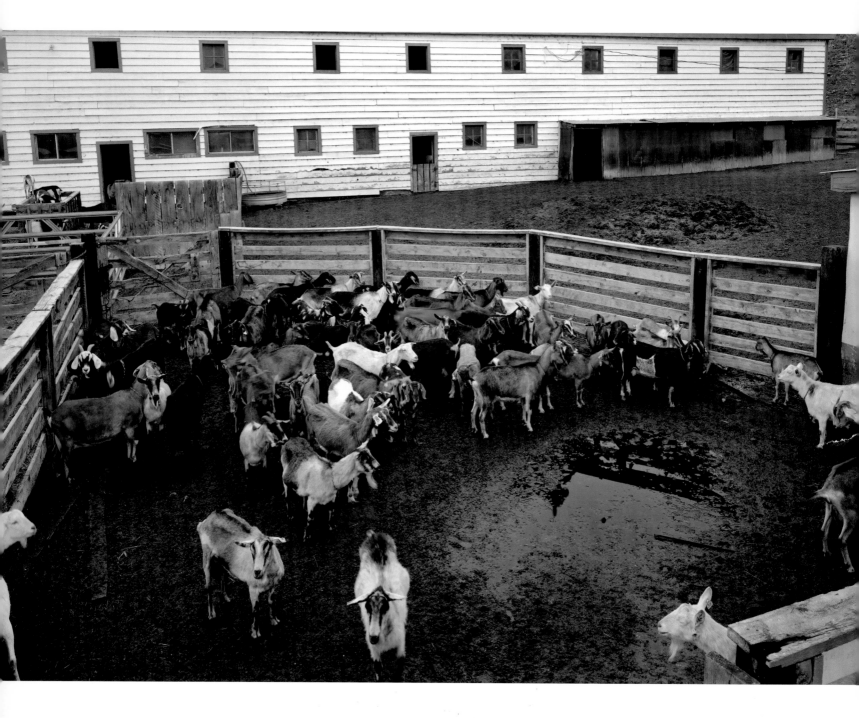

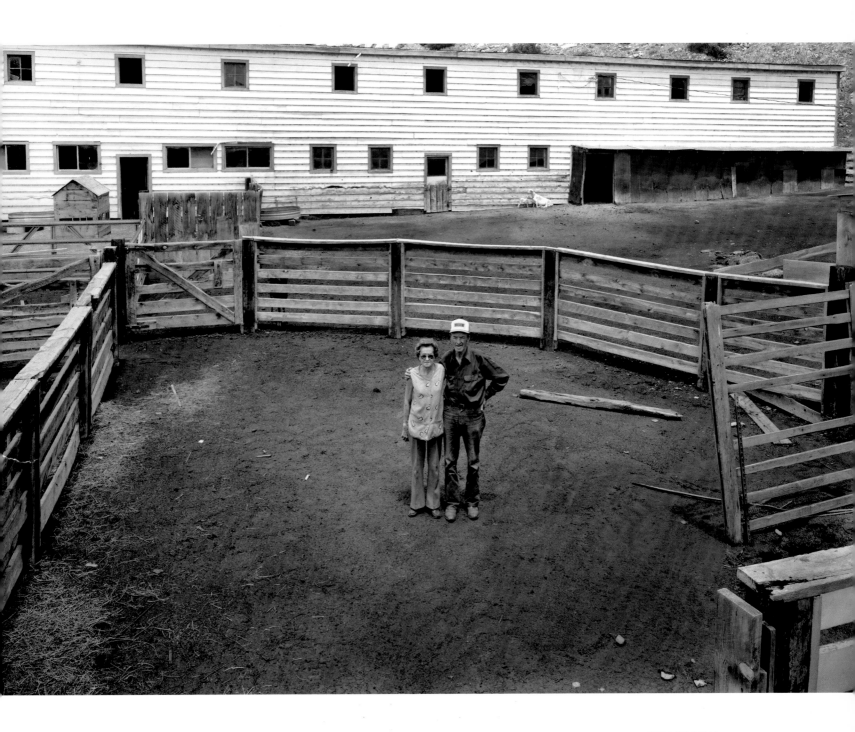

4 Tide-Wed-7
THUR-8 → WA going Slow down slow
6-Feet To-Go
FRiDAY-9 →
SATURDAY → 10
SUNDAY → 11 → ARMY GAURDS ON STREETS 12:00 P.M. "Be Cool!"
ee MONDAY → 12 → ARMY drive throug
CONSTRUCTION CREW CLEAR STREETS O
AND STUFF; Also TOUR BUS PASS BY,
BY ARMY TROOP; Right Now TH
Right iN FRONT OF THiS Buildi
I don't WANT TO TALK At th
TO NO Body; PERiO
WATER
down
AND
OFF
THiS Section TodAY →
Tuesday → 13 → ARMY All over
EVERY WHERE; BUT NO LiGHTS; Y
UL ... → ARMY GAUR

GSAC

SUNDAY → 18 →
I SAY J.R. + dAddy GeRAld FRENC
QuaRT
MondAY → 19 → SALVATioN ARM
Monica's
domino's Pizza 11:30AM; BRought
me BACK To LiFe; thank you very much!
TuesdAY 20 → So FAR oK!
Just A-Little HANSoVER!
It Comes with The TeRRitoRy!
MonicA A #
443-286-0455
... 21 → GEt FeteR iN THIS SPOT!
... → 22
... → 23 ... → W/Ndy
COOLER ... → I went to
Y got LoAded
... on you!
... → 24
... down Town?
... doing To Good To
... EY is VERY, VERY

BREAK-off 9-21-05
Rsy-food off 9-13-05
No police Fool wit

holdouts

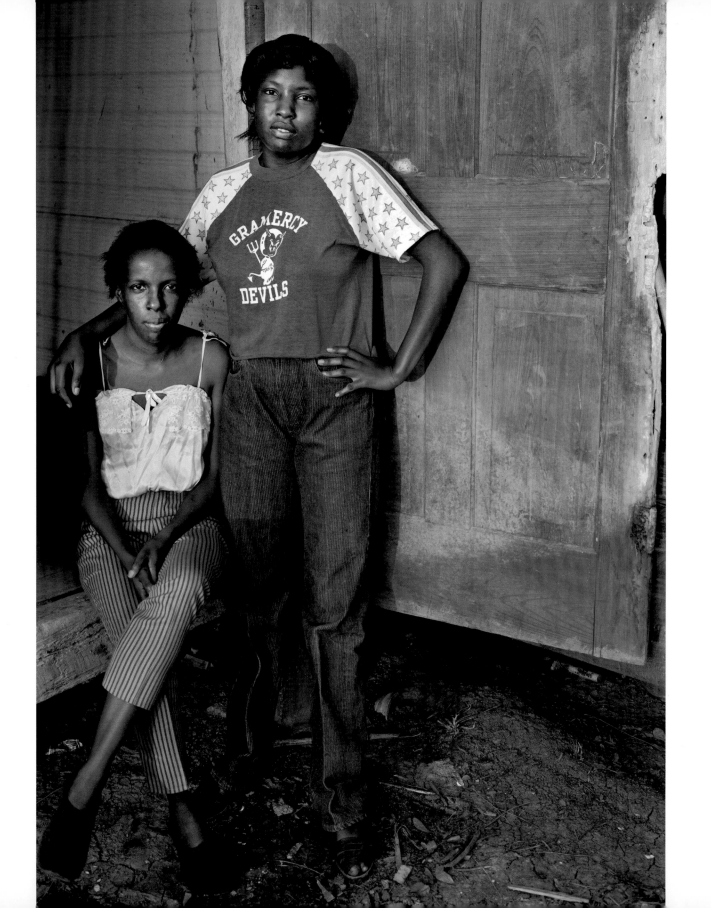

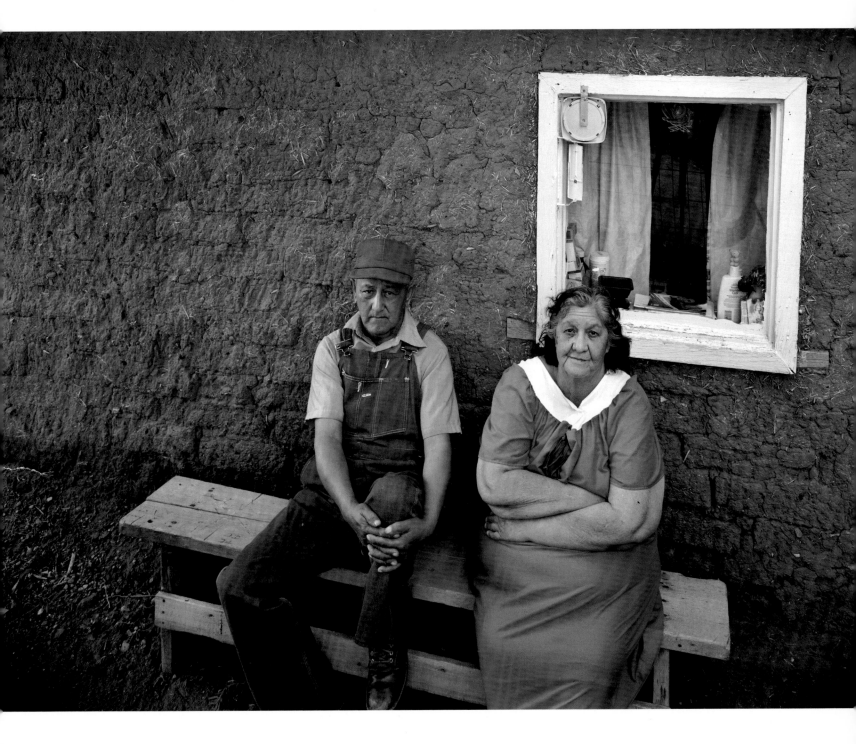

(History)

Hurricane Katrina: The Aesthetics of a Disaster
by Tony Lewis, Ph.D.

In 1757, British politician and prolific writer Edmund Burke published *A Philosophical Inquiry into the Origin of Our Ideas of the Sublime and Beautiful*, a foundational attempt to grapple with the appeal of visual and textual representations that arouse painful or joyous emotions. Burke described the sublime as a state of astonishment, or "that state of the soul, in which all its motions are suspended, with some degree of horror." While the beautiful, for Burke, relaxes and uplifts the body, astonishment initiates a sort of physical pain that tightens the corporeal fibers and makes lived experience all the more precious and profound. Above all, Burke's audience expected that to experience such astonishment had a moral purpose—it offered the opportunity to identify with the sufferer and thus exercise one's capacity for sympathy. This, according to the logic of Enlightenment philosophy, provided a check against the excesses of radical individualism and pursuit of selfish interest.

Traces of the Burkean sublime have reappeared in media and artistic responses to recent disasters, notably the visual culture associated with the human tragedy wrought by Hurricane Katrina and the recent earthquake in Haiti. In each case, media coverage emphasized astonishment with the magnitude of destruction and suffering. Katrina demonstrated that even in contemporary America death does occasionally have the capacity to shock by unexpectedly impinging upon daily life. Katrina showed us the uncanny, or in the words of Julia Kristeva, author of *Powers of Horror*, the abject, which is to be shocked by the difference between living and non-living. In other words, Kristeva's sense of the abject is to know instantly what it means to be living through the repulsive experience of viewing a dead body. Astonishment came to us not only in bold headlines, sensational language, and shocking images of corpses that appeared in the press, but also in the lack of stable, conventional modes of representation and gaps in narration. Depictions of Katrina, at least in the early days, were both shockingly literal and unmediated by stable, Burkean references that had provided earlier audiences for disaster images a readily accessible means of expressing sympathy. These images were at once horrifying and indescribable. Yet we could not turn away.

Katrina presented a spectacle of a city, or society, removed from the usual symbolic order, and further provided an opportunity to overturn and reexamine social conventions. Together with the usual stories of looting and lawlessness, narratives quickly emerged of the supposedly cultured pillar of society acting like a street thug—an Uptown lawyer lying in wait with his guns loaded—or the modest individual rising to the occasion and emerging a hero, such as the man who helped his neighbors move from roof to roof in the Lower 9th Ward.

In contrast to photographs of Hurricane Betsy, which suggest a reticence to confront death, the public initially embraced and was moved by the horribleness of Katrina. But the hurricane revealed a new kind of taboo—an inability or unwillingness to squarely confront issues of poverty, class and race. How one responded to the plight of those stranded at the Ernst N. Morial Convention Center or the Superdome depended, to a degree, on one's political orientation. After the initial shock dissipated, observers tended to channel sympathy into indictments of the

government response, as evidence of institutional racism, or, alternately, toward assigning blame to the victims for their failure to heed warnings or inability to help themselves.

One constant was outrage at the ineffectiveness of politicians and institutions. Criticism extended to all levels of government and across party lines, with local, state, and national leaders sharing the blame. Our Democratic Mayor Ray Nagin and Governor Kathleen Blanco were cited for ineffectiveness and aloofness. Victims and observers alike lambasted organizations, such as FEMA and the Army Corps of Engineers, who built the failed system of levees responsible for much of the flooding in the city. However, the lion's share of the blame fell squarely on the shoulders of Republican President George W. Bush. He and FEMA head Michael Brown emerged as walking metaphors of ineffective response. For many, the opinion was confirmed when Bush initially surveyed the devastation wrought by the hurricane from the insulated distance of 10,000 feet aboard Air Force One.

When Bush did later set foot in New Orleans seventeen days after the storm, he arrived at night under artificial lights powered by temporary generators in a deserted Jackson Square, an area untouched by the worst aspects of the storm. Bush spoke of the "cruel and wasteful storm" and "a tragedy that seems so blind and random." Yet Bush also explicitly referenced America's capacity for empathy: "You need to know that our whole nation cares about you, and in the journey ahead you are not alone." He added, "To all who carry a burden of loss, I extend the deepest sympathy of our country." There is little need to point out that the rhetoric would have a hollow ring when measured against the continuing deprivations and lack of swift and substantive federal aid. New Orleans looked elsewhere for symbols of hope among the volunteers from churches across the country, celebrities such as Brad Pitt, and ordinary, anonymous acts of charity and empathy. Observers, to a certain degree, salved their consciences with donations to the Red Cross or Oxfam, made all the more convenient, painless, and remote through the agency of telethons, on-line communities, and $10 donations via the Internet.

The magnitude of the disaster continues to emerge as New Orleanians deal with the psychological scars. In extreme cases, these scars bear witness to early medical writer Benjamin Rush's observation in 1812 that "terror has often induced madness in persons who have escaped from fire, earthquakes, and shipwreck." Today, such derangement merits the clinical label "post-traumatic stress." According to an article by Mordecai N. Potash published in *Psychiatry* (June 2008), a Kaiser Family Foundation survey of 1,500 New Orleans residents conducted in 2006 revealed that 18 percent self-reported mental health issues. At the same time, only 42 of the 208 pre-Katrina psychiatrists had returned to the city, and as few as 17 beds were available for acute care, mental health patients. Of course, anecdotal evidence points to many who escaped the worst, yet still experience a generalized sense of anxiety, a kind of mental paralysis silhouetted against the promise of a redemption that always seems just over the horizon.

Considered as a group, photographs made in the wake of Hurricane Katrina fit within the Burkean tradition, serving the crucial socio-cultural function of helping to make sense of one of the most profound natural and man-made disasters to affect the U.S. The first images from the media—notably on CNN, and in *The Times-Picayune*, *The New York Times* and *Washington Post*—were raw and unmediated. About half the photographs related to Katrina that appeared in newspapers during the first month focused on themes of human conflict, anguish, or the expression of extreme emotion. The initial reaction of journalists, photographers, and videographers conveyed the scope of the destruction in the context of sudden upheaval, crisis and collapse of meaning. It seems astonishing and unfathomable indeed that systems failed so inexorably and that aid was so slow in coming. Images provoked a shock of confrontation, otherwise unimaginable, that bloated bodies floating in fetid water or abandoned corpses

common witness

propped in wheelchairs could populate the streets of a major American city. Once the initial desire to see the stark reality of death and extraordinary suffering was sated, however, offering ever more horrifying images risked subversion of the affective response. The overload serves to "deaden consciences," as Susan Sontag put it in *On Photography* (1977), or "confirm what we already know" as she wrote in "Looking at War" (2000). Put another way, *schadenfreude* has a short shelf life.

The photographers and journalists who sustained interest in the disaster turned their attention to what may be conceived generally as an aesthetic response to disaster. A typology of images emerged, with broad categories moving on a continuum from corpses and scenes of imminent peril; to heroism or rescue; to suffering residents; to landscapes and damaged buildings; to abstractions inspired by detritus; to rebuilding or, in many cases, failure to rebuild; to allegorical images, including political critique, personal experience, irony, and humor; and, finally, to lyrical or poetic images.

To return to Burke's original definition of the sublime, many artists discerned magnificence in Katrina's destructive power. Artist Phil Sandusky wrote in *Painting Katrina* (2007) of "feeling like a kid in a candy shop" working in the Lower 9th Ward. "Artistically," he continued, "these things we saw were so beautiful." Sandusky's appreciation of the beauty is moderated by guilt about his self-interest in producing a body of work, or in his words, an "internal conflict between my artistic motives and the need to demonstrate my sadness for all the pain and misery Katrina had inflicted on my beloved city." Yet, he finds accommodation within his conscience in the idea that his "paintings were more emotionally charged, knowing that so many people died there."

Sandusky's paintings—as much as J.M.W. Turner's painting of Parliament burning or the photographs of Lori Waselchuck— force viewers to confront the existential possibility of one's own death and come out the other side with a profound empathy for those who have suffered. For Burke, this was the very measure of the transcendent sublime. In 2007, Michelle White observed a similar dialectic in her essay "The Aesthetics of Disaster: Live, Broken and Pretty." Katrina photographs, she noted, offer redemptive "visual and narrative strategies that have personal meaning and critical power." This recalls Rush, who had nearly two hundred years earlier observed that "it is a singular fact, that a tragedy oftener dissipates [low spirits] than a comedy." Art that partakes of various forms of unpleasantness in this way holds the promise of a kind of catharsis.

As Steven Maklansky observes, the photographs taken by the twelve selected photographers bears common witness to the communal despair experienced in the wake of Katrina. In the face of crippling disaster, the urge is to *do* something... anything. First responders administer first aid. Politicians hold press conferences. Photographers take photographs. In the years that have passed since Katrina made landfall, hundreds of professional and amateur photographers have tackled the subject, oriented from journalistic, documentary, and fine arts perspectives. They have attempted to capture the fullness of the storm and its aftermath, with responses that range from recognizing the "decisive moment" to the lyrical and ironic.

The cynic may complain that any number of photojournalists and fine arts photographers exploited Katrina for their own ends; that in the early stages at least, instead of shooting photographs, they should have intervened; or that Katrina has been finished as a subject for artists for some years. The cynic may also agree with Sontag that the sheer number of photographs have the effect of deadening consciousness—furthering the diminishing slope of public interest conceived as a "bell curve" by Maklansky.

Yet it is also possible, from the Burkean perspective, to envisage the creation and consumption of Katrina photographs as akin to a ritual of purification, even a quasi-religious experience. In 1940, as another kind of storm was raging in Europe, Walter Benjamin suggested in "On the Concept of History" that a

painting by Paul Klee entitled *Angelus Novus* evoked a spirit of redemption. It is possible to see the photographs in this book as instruments of Benjamin's Angel of History, who wishes to pause to "awaken the dead and piece back what has been smashed," but is driven "irresistibly into the future." The representations of Katrina hold the promise of helping us come to terms with injustices (make peace with the loss of life), right the wrongs of the past (the political and engineering failures), and restore hope for the future (rebuild the city). The questions each of us must ask are: Do the photographs of Katrina or, more recently, the earthquake in Haiti have the power to astonish us in the Burkean sense? Will the idea of progress blind us to the catastrophe of 2005, leaving both physical and psychic rubble behind? As we internalize these images and make them part of our individual and collective memory, if we can see them as calls to action, that can make all the difference.

individual

and collective

memory

(Afterword)

The What and the How of It
by John Biguenet

In those first days after defective levees designed and built by the U.S. Army Corps of Engineers crumbled and inundated 80% of New Orleans—an area seven times the size of Manhattan—with saltwater up to twelve feet deep, the problem for writers and artists and musicians was not just what to say about this manmade catastrophe but how to say it. For there was nothing in the canon of American literature or the traditions of the visual arts or music in this country that could offer models we might imitate. Never before had the United States seen a major city destroyed, so how were we to represent what had been visited upon our city by an agency of our own government?

And there was a second issue to confront: who was our audience? The impulse of many of us was to put aside our creative projects—our sonnets and novels, our sculptures of the human form, our love songs, our photographic studies of shadow and light—and author instead urgent bulletins to the rest of the world about the desperate plight of our city, about the suffering of our fellow New Orleanians, about their abandonment by the government.

We countered the denials of the U.S. Army Corps of Engineers, who continued to maintain for months, despite the gaping breaches visible in the levees across the city, that they had been overtopped by a storm surge. So we wrote about how the incompetence and indifference to their duty of the Corps of Engineers had killed a thousand American citizens. We photographed the houses sheared in half when the Industrial Canal levee failed and sent an eighteen-foot high wall of water roaring down the streets of the Lower Ninth Ward at five feet per second. We captured images of the intricate arabesques of mold spiraling up the walls and over the ceilings of our ruined homes, of scales of gray mud crusting every surface, of bloated bodies floating in the fetid water that submerged our city for weeks. We recorded what had happened—what was happening—to a city that belonged not just to the United States but to the world.

There was a second audience, though, to whom we had to speak at the same time we were begging for help. In those first months after the flooding of the city, only ten percent or so of the nearly half-million people who had lived in New Orleans were able to return. Because of the absence of housing, of medical care, of schools, well over 400,000 were stranded across the rest of the country. Every essay, every photograph about the devastation of the city had to take into account that its subject—the rotting house, the looted store, even the corpse uncovered months later in the debris—was the home, the livelihood, the relative of someone who might see our work in a shelter in Houston, in a motel in Atlanta. So we all faced the difficult task of revealing the horror of the disaster while veiling with discretion what we could out of respect for the survivors, whose wounds remained raw and open.

And then there was another problem for the writers and artists and musicians and photographers who had returned—daily life in a city in ruins. For the first few weeks, after spending a sweltering day gutting what was left of our house, my wife and I slept in a daycare center with no hot water. That same month I wrote fifteen columns and shot two videos as a guest columnist for *The New York Times*. Those columns were written on a portable computer

how to say it

resting on a bright red table only eighteen inches high while I sat on a preschooler's yellow twelve-inch chair. Then I had to find a wireless signal I could use to send my column to New York. To transmit my four-minute videos to the *Times*, I had to break the film into five-second segments that could be handled by the haphazard Wi-Fi arrangements I was able to make. Sending the video segments, which were then edited in New York, took hours. Photographers and artists and musicians faced similar problems in a city where the few open grocery stores closed at five, where there was no reliable mail service, and where with streets littered with nails and other debris, it could take days to have a flat tire fixed.

Finally, we were all in shock. It's one thing for an individual to lose a house in a fire. At least your friends or family can take you in. Your job is still waiting for you. The coffee shop where you read the paper every morning is still open. You may have lost your home, but the intricate network of people and places that constitutes your life has suffered no disruption. None of that holds true when your entire city has been destroyed. Not only is the coffee shop in moldering ruins, but even the daily newspaper you read there over a cup of chicory coffee cannot—at least in the beginning—be published. Your utterly secure job has vanished in the deluge. And as for your friends, their houses, too, are still soggy with floodwater. You don't even know where they are, whether they've survived.

It was in such a shattered city that the photographers and artists and writers and musicians of New Orleans managed to get the story out. There was a price, though, to be paid, whether it was a photographer begging to be shot in a standoff with the police, a young filmmaker murdered in her own home in the lawless chaos into which the city descended, or couples divorcing as husband or wife declared to the other that they could love that person anywhere on earth—except New Orleans.

For me, I was able to write through the whole ordeal, but I lost the ability to read. Even sitting through a film was agony. I think I was holding on so tightly, with such focused attention, to the myriad of problems that beset us—housing, jobs, money, looters, health care, insurance—that I simply found it impossible to relax my imagination long enough to slip the bonds of the self and inhabit an invented character on the page or the screen. Others complained of similar incapacities.

But even being able to write, I wasn't sure what to write. We had known how to depict New Orleans before the flood: each art form here had its conventions, nearly all muddying the threshold between past and present. Jazz, for instance, usually took flight from an old song and came home to it at the end. Writers here made more use of ghost stories than authors elsewhere in America. Photographers situated the present under the mossy arches of the past. All of us, in one way or another, depicted life among the ruins.

Since the destruction of the city, though, we are adrift in the present, far from the familiar coastline of the past. What conventions exist to depict something that has never happened before? What American novel traces the eradication of one of our cities, the exile of two hundred thousand citizens, the obliteration of a set of intertwined cultures centuries old? Do we have a musical idiom for the wail of lamentation such loss engenders? And what is it our photographers could shoot and our artists paint that might frame in an image the vast devastation of the city?

Because I had no models, for me it seemed necessary to start small, to confine the dimensions of the story I wanted to tell. So I wrote a play based upon one of my *New York Times* columns, "How They Died." In *Rising Water*, a couple awaken in the middle of the night to find their pitch-dark house filling with water. Clambering into their attic, and then onto their rooftop, Camille and Sugar struggle not only to survive but also to keep the guttering flame of their love from being extinguished.

It took ten drafts to find a workable form and to purge the play of my anger. What was left was a first act in a cramped attic,

filled with the mementoes of a lifetime together, and a second act in which Camille is able to escape to the roof but her overweight husband can squeeze no more than his head through the hole he has made to escape the flooding attic. The form revealed to me the subject: the first act would explore memory; the second, dream as the couple discovered in moonlight a city unlike any they had ever before imagined. Camille was light enough to escape the past, but Sugar, weighed down by all the losses they had suffered, found himself stranded between memory and dream, past and future. Others, as this volume documents, invented their own responses to the aesthetic problem of inventing a form appropriate to the catastrophe.

We all of us were changed by what we experienced and what we witnessed. How did so much suffering remake us as writers, photographers, artists, musicians? We are only now just beginning to discover what it's done to us. But like Sugar, we are trapped between the New Orleans we remember and the new New Orleans that still seems a kind of dream. Some have retreated to the attic; some are pacing the rooftop, knowing help is unlikely to arrive.

So those are the circumstances in which many of the photographs of this volume were made, photographs that document a nearly incomprehensible event in which the richest and most powerful nation on earth allowed over one thousand of its citizens to drown in their own homes or die of dehydration trapped in suffocating attics and on scorching rooftops in the days that followed the collapse of defective levees.

These photographs bear witness to a great crime, a crime for which no one has been held accountable. But thanks to these photographers, at least history will be able to bring its irrevocable judgment to bear on the destruction of New Orleans.

like a d r e a m

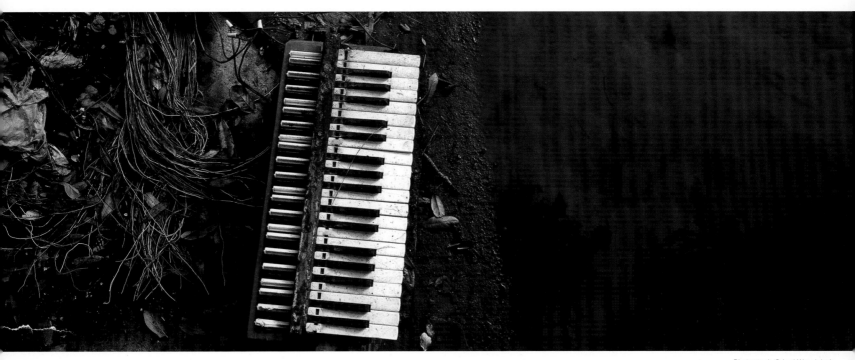

Photograph © Lori Waselchuk

(Biographies)

PHOTOGRAPHERS

Eric Julien was born in New Orleans. Inspired by the vibrancy of Haiti and New Orleans, whose cultures were impacted by French, West African, and other cultures, his images capture their common heritage. In the past ten years, Julien's photography has been in numerous exhibitions in New Orleans, as well as at the Tisch School of Art in New York City and at the Contemporary Arts Center in Cincinnati, Ohio. His collage work was part of a juried show at the Museum of Science and Industry in Chicago in January 2008. Julien's work has been published in *Callaloo*, *Tulane Arts Review*, and *Our Roots Run Deep*. In 2008 he received the Excellence Award from *Black & White Magazine* for his Isle of Hispaniola series. Since Hurricane Katrina, Julien also paints and creates mixed-media work.

Elizabeth Kleinveld is a self-taught artist and photographer. In the 1990's, Kleinveld used a variety of media to produce work inspired by Mexican folk art and the Cobra movement. After Katrina, Kleinveld was compelled to capture the storm's wrath using a totally different media—the camera. Kleinveld returned to her hometown six times in the year after Katrina to shoot the devastation, at first with a wide-angle lens and later with a close-up lens. In 2007 Kleinveld began creating a series of flowers reflected under water, giving her work an abstract and painterly quality. Kleinveld's work has been shown in the United States Senate, New Orleans Museum of Art, and Colorado Springs Fine Arts Center, as well as a number of locations in the Netherlands. Her work is held in both private and public collections in the United States and Europe, including the New Orleans Museum of Art, the Louisiana State Museum and the Dutch Embassy in Washington, D.C.

Rowan Metzner, a native of New Orleans, received a BFA in Photography from Rhode Island School of Design in 2007. Before the storm, Metzner worked with traditional 35mm in black and white, concentrating on abstract portraits of the body. After going back to New Orleans to help her father clean out his Katrina-damaged house, she decided to use color photography to show how the hurricane had changed the natural color of the landscape, making it almost void of color. Upon returning to RISD, she spent a year in Rome where she continued to work in color. Troubled by the drowning and destruction of her hometown, she evokes a sense of foreboding and doomsday in her post-Katrina series. Metzner's work is housed in both public and private collections, including the Aaron Siskind Center at the RISD Museum and the permanent collection of the American History Museum at the Smithsonian. In 2007, Metzner was a winner of the Chelsea International Fine Arts Competition. Her work has been shown in galleries in Michigan, Montana, New York, Rhode Island and Italy.

As a prominent photojournalist in Louisiana, David Rae Morris's images have been published in *The New York Times*, *Time*, *Newsweek*, and *USA Today*, among others. He is co-author with his late father, Willie Morris, of *My Mississippi*, published by the University Press of Mississippi in 2000, and *Missing New Orleans*, published by the Ogden Museum of Southern Art in November 2005, ten weeks after Hurricane Katrina made landfall. Morris's photographs are in many private and public collections including in the permanent collections of the Ogden Museum of Southern Art, the Louisiana State Museum, the New Orleans Museum of Art, and Mississippi Museum of Art in Jackson, Mississippi.

Thomas Neff is a professor in the School of Art at Louisiana State University (Baton Rouge), where he has been teaching photography since 1982. The numerous bodies of work he has created focus on people, place, and architecture in Italy, Ireland, China, Japan, Colorado, and Louisiana. In 2006, Neff's series of portraits and written narratives of people in New Orleans, citizens who did not evacuate when Hurricane Katrina struck, was shown at the Ogden Museum of Southern Art. The University of Missouri Press published this work in 2007, under the title: *Holding Out and Hanging On: Surviving Hurricane Katrina*. Neff has been the recipient of grants from the NEA and the Louisiana

Division of the Arts, and his work is found in the collections of the California Museum of Photography (Riverside), the Houston Museum of Modern Art, and the Harry Ransom Humanities Research Center at the University of Texas (Austin), the Louisiana State Museum, among others.

Samuel Portera was born in New Orleans, Louisiana, and raised in the marshes and bayous of St Bernard Parish. Portera, a self-taught photographer, discovered his passion for photography fifteen years ago, and since that time he rarely leaves home without his camera. Most well known for a series of post-Katrina landscapes, which were self-published in *After The Water*, his latest series, *Deadwater*, focuses on the unique beauty of Louisiana's wetlands. Portera uses a vintage brass lens to lend a sense of antiquity to his photographs. This work serves as a historical impression of a landscape that he believes to be threatened. Portera's work has appeared in photography magazines, including *Black & White Magazine* and *Shots Magazine*, and has been featured in the following exhibitions in New Orleans: Louisiana Vision/Re-Vision, Rituals and Revelries and Toy Stories. Together with Jennifer Shaw and Eric Julien, Portera's work was part of a group show at SOHO PHOTO in New York in September 2008.

As a Louisiana native, Frank Relle grew up inspired by the architecture that characterizes New Orleans. The unique juxtaposition of small shotgun homes in the Ninth Ward against the backdrop of Greek-inspired colonnaded mansions in the Garden District evokes a sense of romance and mystery for which the city has been famous for hundreds of years. Relle is most well known for his series, Nightscapes, which provide a unique perspective on the quintessential architecture of New Orleans. The scenes he creates are developed by a special method to light the subject, using a combination of high-pressure sodium, mercury vapor, and daylight-balanced hot lights. Relle uses a long exposure time to create movement, color combinations and cloud formations, giving an eerie stillness to his work.

Jennifer Shaw, a fine art photographer who lives in New Orleans, spent most of her formative years in Milwaukee, Wisconsin, where she first learned her way around the darkroom at the age of fifteen. She immersed herself in the medium, and went on for further study at the Rhode Island School of Design, earning a BFA in Photography in 1994. Before Katrina, Shaw spent several years photographing the post-industrial urban landscapes along New Orleans's Mississippi riverfront in black and white. A year after the storm, she began using color photography and employing toys to narrate her evacuation saga, including the birth of her son a day after Katrina. Shaw's work has been featured in several issues of *Shots Magazine*, as well as *Light Leaks Magazine* and *The Sun*. Her photographs have won awards in national exhibitions and are held in both private and public collections, including the Huntsville Museum of Art, Huntsville, Alabama, the New Orleans Museum of Art and the Ogden Museum of Southern Art, New Orleans.

Mark J. Sindler is a photographer, documentary video producer, and media arts educator who has lived in New Orleans for many years. His still images have been featured in *Folklife in Louisiana Photography*, *New Orleans: An Epic City*, *Katrina Exposed*, and *Stir It Up: A History of Cajun Cuisine*, and they have appeared in periodicals such as *Louisiana Life*, *New Orleans Magazine*, *The Times-Picayune*, *Cultural Vistas*, *The Miami Herald*, *American Heritage*, and *The Village Voice*. Specializing in visual anthropology, Sindler has received grants from the Louisiana Division of the Arts and the National Endowment for the Arts, and his photographs are in the permanent collections of the following Louisiana institutions: New Orleans Museum of Art, Jean Lafitte National Historical Park, Southeastern Louisiana University and Louisiana State University. Sindler has produced documentaries for Louisiana Public Broadcasting and the Contemporary Arts Center of New Orleans, and as a media arts educator, he has taught video production for the U. S. State Department in Kazakhstan, as well as developed and led training programs for inner-city youth, Native Americans, and inmates at Orleans Parish Prison. Presently, Sindler serves as chief photographer for the Louisiana State Museum system, for which he has been chronicling the devastating aftermath of hurricanes Katrina and Rita.

Zack Smith, a native of Lafayette, Louisiana, has been documenting the social landscapes of New Orleans and Southern Louisiana for the past nine years. Smith is well known for

documenting varied aspects of New Orleans culture, particularly its music scene. In addition to being a photography instructor at The New Orleans Academy of Fine Art, Smith also works with many private portrait clients in the New Orleans area. Smith's photographs have been featured at Mu-Terem Gallery, Debrecen, Hungary and Austin Museum of Art, Austin, Texas, as well as such local venues as The New Orleans Academy of Fine Art and Jonathan Ferrara Gallery, among others.

Jonathan Traviesa is a photographer and artist living in New Orleans since the late 1990s. He has had numerous solo and group exhibitions in New Orleans, Philadelphia, Chicago, and New York. In 2005, *The Times-Picayune* voted his Katrina photo-sign installation best art show of the year. He has been teaching Photoshop at NOAFA since 2005. In 2006, he and Valerie Massimi under the collaborative team, "Victor & Juliet" began to develop various sculptural installations in New Orleans. Traviesa is a founding member of The Front gallery and released his first book, *Portraits* with a concurrent exhibition at The Front during October and November of 2009. As part of PhotoNOLA, Traviesa received the New Orleans Photo Alliance's inaugural Michael P. Smith Grant Award, and the Ogden Museum of Southern Art exhibited a selection of his portraits from the book. His work is collected privately around the United States and publicly in New Orleans by the Ogden and the New Orleans Museum of Art.

Lori Waselchuk strives to contribute to a community dialogue through documentary photography. Waselchuk's photographs have appeared in magazines and newspapers worldwide including *Newsweek*, *LIFE*, *Esquire*, *The New York Times* and *The Los Angeles Times*. She has produced photographs for several international aid organizations including CARE, the UN World Food Program, Médecins Sans Frontières, and The Vaccine Fund. Waselchuk is a recipient of the Aaron Siskind Foundation's 2009 Individual Photographer Fellowship; a 2008 Distribution Grant from the Documentary Photography Project of the Open Society Institute; the 2007 PhotoNOLA Review Prize; and the 2004 Southern African Gender and Media Award for Photojournalism. Waselchuk was also a nominee for the 2009 Santa Fe Prize for Photography; a finalist in the 2008 Aperture West Book Prize; and a finalist in the 2006 and 2008 Critical Mass

review. Lori Waselchuk exhibits her work internationally in solo and group shows. Her work is included in several photography books including *A Day in the Life of Africa* (2002) and *Women by Women: 50 Years of Women's Photography in South Africa* (2006). Currently, she continues her work in Louisiana with a project on the bridges of New Orleans with the generous support from the Baton Rouge Area Foundation. Her exhibition, Grace Before Dying, a photo essay about the hospice program at Angola Prison, is touring Louisiana state penitentiary facilities, libraries, community centers, and museums.

WRITERS

John Biguenet's fiction, poetry, and essays have appeared recently in such journals as *The New York Times Book Review*, *Washington Post*, *Esquire*, *Granta*, *Story*, *Zoetrope: All-Story*, *DoubleTake*, *Ellery Queen Mystery Magazine* and *Ploughshares* as well as in various anthologies. His new play, *Rising Water*, was nominated for the 2008 Pulitzer Prize in drama. *Shotgun*, his second play in his *Rising Water* cycle, premiered in 2009. Among other distinctions, his work has received an O. Henry Award and a Harper's Magazine Writing Award. He has served two terms as president of the American Literary Translators Association. Formerly Writer-in-Residence at the University of Arkansas at Little Rock and at the University of Texas at Dallas, he is currently the Robert Hunter Distinguished Professor at Loyola University in New Orleans, where he has been honored with the institution's Dux Academicus award for outstanding teaching, scholarship, and service.

Steven Maklansky is the President, CEO, and Director of the Brevard Art Museum in Melbourne, Florida. Prior to taking that position in March of 2009, he served as the Director of Curatorial Services at the Louisiana State Museum. In this capacity he assisted the Director in all phases of the museum's administration including long range planning, exhibitions and collections, fundraising, public relations, and daily operations. He supervised the Collections Division and Interpretive Division Directors and oversaw all curators, historians, registrars, and other professionals in the divisions. He was responsible for the Museum's hosting of three nationally traveling exhibitions: GOLD which originated at the American Museum of Natural History,

Let Your Motto be Resistance from The National Portrait Gallery, and Treasures of Napoleon, which was drawn from an incredible private collection. Maklansky was previously employed as the Assistant Director of Art and Curator of Photographs at the New Orleans Museum of Art. During more than a dozen years of service with the museum, he curated 33 exhibitions of photographs that explored subjects as diverse as the distinctions between art and pornography and the history of African American family photography. His exhibition Katrina Exposed, featuring some 700 photographs covering the aftermath of that tragic event, was named the Best Exhibition of 2006 by *The Times-Picayune*. Maklansky has published many catalog essays and he has lectured widely on the history of photography.

Dr. Tony Lewis is the Curator of Visual Arts for the Louisiana State Museum. Dr. Lewis completed a doctorate in the history of art, with a specialization in nineteenth-century American art, at Northwestern University. His dissertation focused on Thomas Birch's paintings of shipwrecks, seascapes, harbor scenes, naval battles, and ship portraits. Before joining the Louisiana State Museum in January 2007 as Curator of Visual Arts, he served as a multimedia content developer at the National Gallery of Art in Washington, D.C.; as Curator of Paintings, Prints, and Drawings at the Mariners' Museum in Newport News, Virginia; as Assistant Director of the Middlebury College Museum of Art; and as a professor of Art History and Museum Studies, and Museum Director, at the University of Southern Mississippi in Hattiesburg. During his career, Dr. Lewis has curated over forty exhibitions and has published several articles, essays and exhibition catalogues. His most recently completed works include: a book on architectural photographer Robert Tebbs' images of Louisiana plantations for LSU Press and ten essays for the forthcoming revision of *The New Encyclopedia of Southern Culture* volume on folk art.

CREATIVE DIRECTOR
Tom Varisco is sole proprietor and creative director of Tom Varisco Designs, a full service design / branding studio in New Orleans that has won several awards on the local, regional and national levels for a wide variety of clients. In 2007, Tom was awarded the first "Fellow Award" by the New Orleans chapter of the American Institute of Graphic Arts (AIGA) for design leadership and excellence. His self-published photo book *Spoiled*, about the refrigerators left out after Hurricane Katrina hit New Orleans, was selected one of the top 50 design books by AIGA in 2006. Tom's second self-published book, *Signs of New Orleans*, is a design and photo book that serves as a brief record of the city's "sign language." *Desire*, his award-winning publication of observations and opinions about New Orleans, features original local artwork and writing. Tom teaches graphic design to fourth year students in Loyola University's Visual Arts department. Tom would like to thank Jan Bertman, Gregory Good and Uyen Vu for their design and production expertise and assistance. For examples of the studio work, visit www.tomvariscodesigns.com.

PHOTO EDITOR
Rowan Metzner (see above).

TEXT EDITORS
Anne Gisleson is chair of the writing program at the New Orleans Center for Creative Arts, Louisiana's arts conservatory for high school students. Her writing has appeared in various places including the *Oxford American*, *Best American Non-Required Reading* and *The New Orleans Review*. She also helps run Press Street, a non-profit which promotes art and literature in the community through events, publications and art education.

Constance Adler lives and writes near Bayou St. John. Her articles have appeared in *Spy, Utne Reader, New York Magazine, Philadelphia Magazine, Oxford American*, and *Blackbird*. She has written for *New Orleans Gambit Weekly*, and the Louisiana Press Association honored her work with an award in Feature Writing. She teaches a creative writing workshop of her own design, called The Bayou Writing Workshop. She also writes a blog, "Emily Every Day", about the poems of Emily Dickinson.

Michael Martin is a freelance writer and editor living in North Carolina. His work has been published in a variety of literary magazines, and for many years he was contributing editor for *Amsterdam Weekly*; he co-edited the recent sports anthology, *Rules of the Game: The Best Sports Writing from Harper's Magazine* published by Franklin Press.

imagine a city